Drawing Lab for
Mixed-Media Artists

QUARRY

First published in the United States of America by
Quarry Books, a member of
Quayside Publishing Group
100 Cummings Center
Suite 406-L
Beverly, Massachusetts 01915-6101
Telephone: (978) 282-9590
Fax: (978) 283-2742
www.quarrybooks.com
Visit www.Craftside.Typepad.com for a behind-the-scenes peek at our crafty world!

Library of Congress Cataloging-in-Publication Data
Sonheim, Carla.
 Drawing lab for mixed-media artists : 52 creative exercises to make drawing fun / Carla Sonheim.
 p. cm.
 Includes index.
 ISBN-13: 978-1-59253-613-9
 ISBN-10: 1-59253-613-1
 1. Handicraft. 2. Drawing--Technique. I. Title.
 TT157.S624 2010
 745.5--dc22

 2010000277
 CIP

ISBN-13: 978-1-59253-613-9
ISBN-10: 1-59253-613-1

11

Cover Design: bradhamdesign.com
Book Layout: *tabula rasa* graphic design
Series Design: John Hall Design Group, www.johnhalldesign.com
Photography: Steve Sonheim
Photo, page 54, Getty Images

Printed in China

Drawing Lab for Mixed-Media Artists

52 Creative Exercises to Make Drawing Fun

BEVERLY MASSACHUSETTS

QUARRY BOOKS

Carla Sonheim

Contents

Lab 27: Drawing Clay Creations (see page 76)

Introduction

DRAWING IS FUN! If you don't think so, then you probably haven't drawn lately!

DRAWING IS SCARY. Okay, I know it is scary, too. You feel comfortable with collage or acrylic paint, but not with a pen or pencil. You might have tried to learn to draw from traditional drawing books or classes and felt frustrated, or worse, bored. Perhaps you've tried learning to draw on your own, but are critical of your efforts. (Note: this is not fun.) And yet . . . something inside is telling you to try putting more of your own hand into your work.

Let's put fun back into drawing! I'm hoping to help you begin to see drawing as a pleasurable activity rather than as an opportunity to beat yourself up. Honestly, mark-making is one of our first pleasures as children. We aren't so different now, as adults. One workshop student recently said, "[Being in your class is] like being a child again, but you get to do it as an adult." That is how I hope you will feel as you experience this drawing book.

Left and opposite: Drawing is an integral part of the author's mixed-media work. Pages from Junk Mail Book II, *gesso, watercolor, Sharpie, and charcoal on junk mail.*

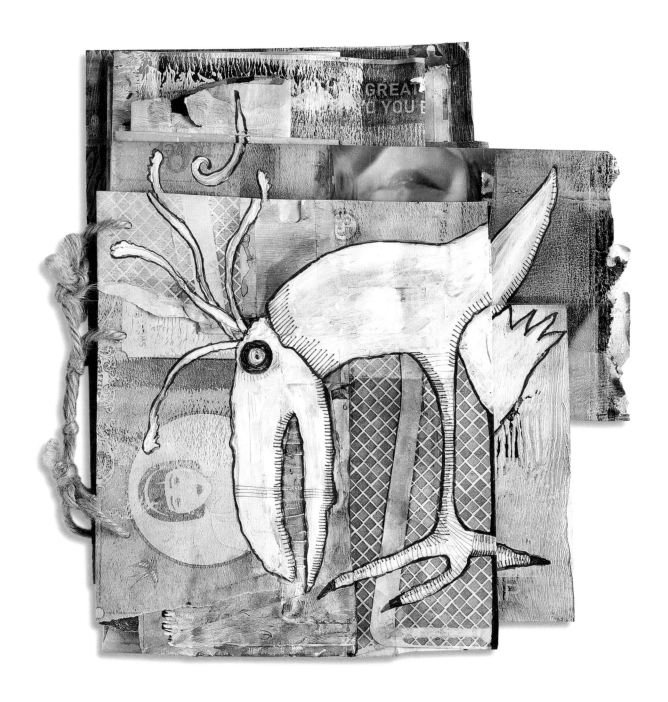

Why Draw?

First the serious stuff: Having a foundation of basic drawing skills will help you in all of your creative work. In the same way that running cross-country can give you skills in perseverance, discipline, and focus, which can affect all areas of your life, the same is true with drawing. The skills you learn by drawing—learning to "see" and focus, developing your "hand," and so on—will be transferred to and influence your paintings, collage, or other artwork.

Simply, by being able to draw like this:

. . . I can, with more confidence, draw such things as this:

. . . and this:

. . . and even this:

Getting Over the Hump

Steven Pressfield writes in his wonderful book, *The War of Art*: "There is no such thing as a fearless warrior or a dread-free artist." He is so right. Even though I love drawing and have completed hundreds of drawings and paintings, each day I have a little mini war with myself when I face that blank page.

One way I've found to get over this block is to have an arsenal of starter exercises (or "assignments") on hand to help me get going: Rules, restrictions, or challenges to work within. And react against. And create in spite of. Limitations keep me from taking me or my art too seriously. They also relieve the pressure of *what to draw* and just get me moving.

Watercolor, gesso, charcoal, and ink on wood

Consider these words by creative people throughout our history:

"The more constraints one imposes, the more one frees oneself of the chains that shackle the spirit." —Igor Stravinsky

"Limit gives form to the limitless." —Pythagoras

"The fewer limitations the artist imposes on his work, the less chance he has for artistic success." —Aleksandr Solzhenitsyn

"The problem about art is not finding more freedom, it's about finding obstacles." —Richard Rogers

"Without firm limits there is no play." —Rem Koolhaas

It's a paradox: when you have complete freedom, you often "freeze up" and do nothing. This book is a compilation of assignments that I have given myself over the years to get myself moving. Others were developed for elementary school-age students. When I started teaching adults, I found these same exercises to be the most effective. (We're all just kids inside still, right?)

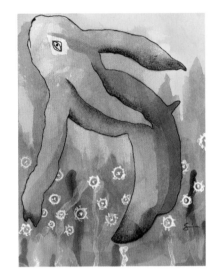

See Lab 8: Imaginary Creatures

What This Book Is . . . and Isn't

Here are three rules I like to follow myself:

1. Draw things you like.
2. Draw with materials you like working with.
3. Draw using styles, methods, or processes that you like.

This book includes many traditional drawing exercises—contour drawings, blind contours, and gesture drawings, for example—but I've intentionally left out some of the things you might find in traditional drawing books. This book is designed to get you started drawing again, and excited about it! With renewed inspiration, you might like to take your drawing even further. I highly recommend checking out the many excellent drawing books that are available (my favorites are listed in the resources section), and/or taking a class from your local university.

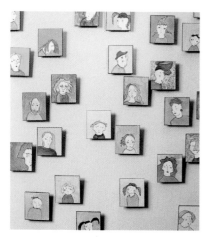

The author's first show, Faces I've Seen, featured one thousand 3-inch (7.6 cm) watercolor paintings of people she had "seen" in her subconscious.

Materials You'll Need

Making art is not about the materials you have, it is about just doing it. If a no. 2 pencil is the only art tool you own, then start there! Here's a quick list of the materials I like to have on hand:

- stacks of white card stock
- 140 pound (64 kg) Fabriano hot-press watercolor paper
- mechanical pencil
- vine charcoal (soft)
- soft charcoal pencil
- red Conté crayon
- Pelikan watercolors (set of 24 transparent colors)
- white FW acrylic ink
- bottles of ink (various colors and brands)
- nib pens
- #12 round brush
- small flat brush
- liner brush
- 01 (0.25 mm) black Pigma Micron pen
- kneaded rubber eraser
- colored permanent markers (such as Sharpies)
- a selection of very light-colored Copic markers
- colored pencils
- water-soluble crayons
- a few soft pastels (red, orange, green)
- glue stick
- scissors
- spiral-bound sketchbook with heavier paper

Find materials you love and can afford, and enjoy them! I use cheap pencils but good paper, good-quality brushes but midgrade paint. The point is that you are the artist. Pick an item from your art stash and start with that. Then add from there, adding only mediums that you really like working with.

Most of the materials listed in the book are easily found. However, if you find yourself unable to find a particular medium, improvise!

All artwork in this book by Carla Sonheim unless otherwise credited.

Opposite page: *Watercolor, gesso, pencil, charcoal, and ink on wood*

About Sketchbooks

For years I couldn't work in a sketchbook because I felt intimidated by the book format . . . if I ruined a page I would ruin the whole book! My solution has been to work on single sheets of white card stock, and just stack the pages on a shelf or put them in a file folder. However, a book is more convenient for on-site drawing, and I've recently had success with a spiral-bound sketchbook. (If I can tear out a page I don't like, I am freer to just draw and create.) Sketchbook or not, it's your choice. Do what feels comfortable for you.

Inspired by Animals

ANIMALS ENRICH US in so many ways . . . the facial expression of an irritated house cat or the sheer bulk of a hippo inspires and nurtures our souls. For me, creating my own menagerie of animals has a similar soul-healing effect.

In this unit you will draw from life, from photo references, and from your imagination. Drawing from life is always preferable, but many people do not have easy access to a lion or a bear. Start collecting pages of animals that interest you, torn from magazines or newspapers. It's best to find imagery that is fairly generic—you just want to get information about the appearance of the animals at this point, rather than picking photos for their compositional values.

The more you draw from life or photos, the richer and more authentic your imaginary animals will be.

Opposite page: This mixed-media Rabbit-Turtle is created with gesso, watercolor, collage, and, of course, line.

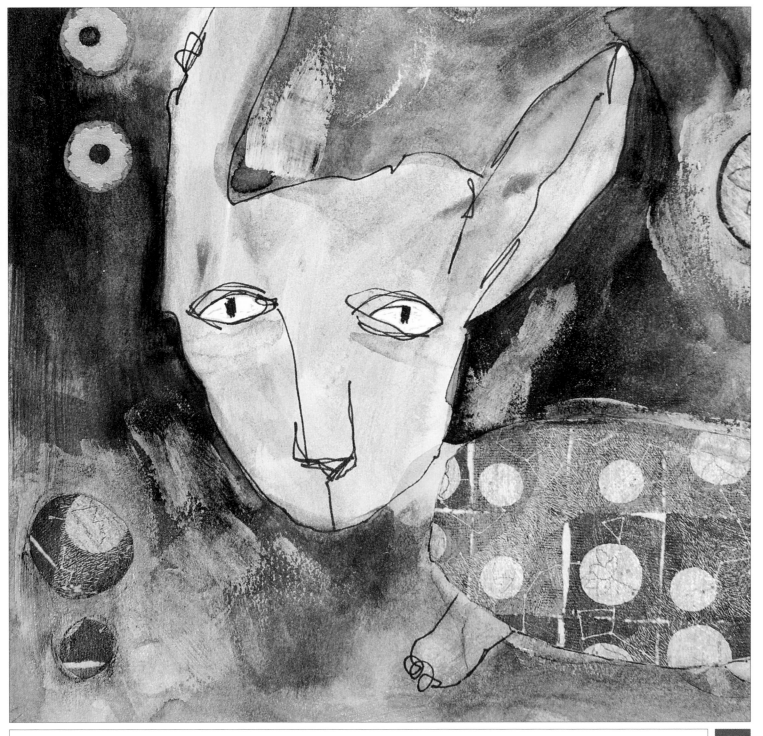

Draw Cats in Bed

- several sheets of white card stock
- colored extra-fine-point permanent marker

"At a very young age, I got in the habit of making things up. I have to feel that I've had my dose of invention for the day."

—John Irving

DRAW ABOUT THIRTY CATS from your imagination while sitting or lying in bed. If you are unsure where to start, go ahead and copy some of the cats on these pages. Or, better, spend some time just looking at a real cat before you do this exercise.

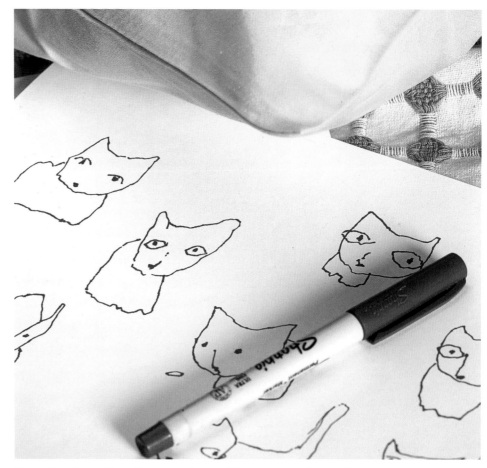

The soft surface of the pillow or mattress will force a looser line quality.

Instructions

1. Gather your materials and get into bed . . . you can either sit up with your paper propped on a pillow, or lie on your stomach with the paper on the mattress.

2. Think about what a cat looks like: ears, face shape, body shape, tail, and just spend the next ten minutes or so drawing as many cats in as many positions as you can think of.

3. Try to keep your lines simple and expressive. If you find that you are feeling tense, switch to your nondominant hand.

4. Don't fret if you don't like many of your cats. It takes many, many drawings to get that "one" that you love.

Taking It Further

Pick one or two of your favorite drawings and render them again in several ways.

Example 1: Paint your cat on wood or canvas using acrylics, oils, or a mixed-media combination such as gesso and watercolor (shown).

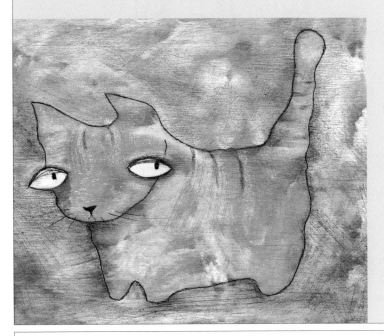

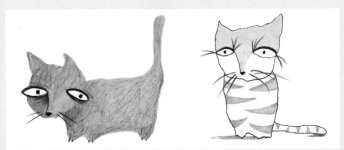

Example 2: Redraw your cats using colored pencils (left) or ink and colored pencils (right).

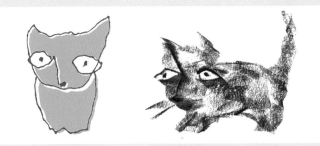

Example 3: Scan your cat into the computer and add a solid color to the inside of your cat, offset slightly, (left). Or use the side only of a ½-inch (1.3 cm) piece of vine charcoal, (right).

Blind Contour Giraffes

- photo references of giraffes

- 5–10 sheets of white card stock

- black extra-fine-point permanent marker

"God is really only another artist. He invented the giraffe, the elephant and the cat. He has no real style, He just goes on trying other things."

—Pablo Picasso

BLIND CONTOUR DRAWING is a classic drawing exercise that emphasizes careful observation rather than a finished product. It is used by many artists as a way to improve hand–eye communication (and, sometimes, as a nonthreatening way to just get the pencil moving). In this exercise, you will draw a series of giraffes without looking at your paper.

By using photo references, you will be reminded of positions that you might not have thought of on your own.

Instructions

1. Find some references of giraffes, either online or at the library.

2. Pick one and fix your eyes on the outline of the giraffe, and start drawing. Do not look at your paper. Look at the giraffe 100 percent of the time.

3. Try to match the movement of your pen to that of your eyes' running along the edge of the giraffe. Draw every curve and bump.

4. Blind contours are usually done quite slowly and in a single, continuous line; think about your speed and consciously adjust it if you think you are going too fast.

5. If you get stuck or would like to move your pen to start an internal feature, it's fine to glance down at your paper to reset your pen to the right area, but don't move the pen while looking at your paper (think of it as "drawing freeze tag").

6. Continue drawing different giraffes for about ten minutes or so.

7. While doing this exercise, you will learn several things about giraffes that you might never have noticed before (such as that their horns are hairy and they have a large bump on their forehead).

Taking It Further

- Of course you can pick any subject matter you wish . . . cats, elephants, birds, horses, dogs, rats . . .

- Inanimate objects such as chairs and cars make interesting blind contours.

- Try layering three or four blind drawings on top of one another on one paper, not worrying at this stage where the drawing is going. Now see if you can pull the drawing together into a cohesive piece by adding lines and color (from your imagination).

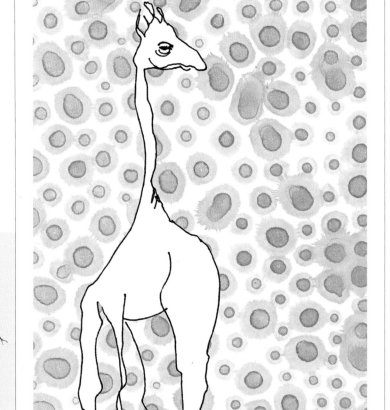

You will get some funny-looking giraffes, but that is part of the fun!

My Pet Project

Materials

- 5–10 sheets of white card stock, or your sketchbook
- charcoal pencil (soft)

DRAWING YOUR PET when it is awake and moving is definitely a challenge, and nearly impossible if you are aiming for a tight, realistic drawing. Instead, you will embrace the life and energy of your active pet with a series of gesture drawings—quick sketches meant to record movement or action. Details not allowed!

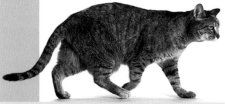

"All of the animals except for man know that the principle business of life is to enjoy it."

—Samuel Butler

The author's pet rat moved at lightning speed; the fact that these drawings even look like a rat surprised the artist more than anyone else. It's amazing what your brain and hand can accomplish if you will only get out of the way!

Instructions

1. Your pet is awake and moving, either playing with a ball, giving itself a bath, or running around its cage. Just watch your dog (or cat or chinchilla) for several minutes before you begin to draw.

2. With your charcoal pencil held loosely in your hand, try to capture the form of your pet with one or two quick lines as it moves through space.

3. It's very likely these first recordings don't say very much at all . . . keep watching your animal, and try again to "shape" the lines into recognizable form with another quick line.

4. These drawings should only take a few seconds each! Think of them as physical recordings of what your brain has already seen and filed.

5. Please do not worry about how these drawings look . . . they are meant as a process exercise only. Especially in the beginning, this might seem like a somewhat pointless exercise. Trust the process, though! Your success rate will go up the more you practice.

6. Spend about ten minutes doing gesture drawings of your pet.

Taking It Further

Try a gesture drawing of your pet's toy, endeavoring to capture the "essence" "or "spirit" of the inanimate object (rather than movement).

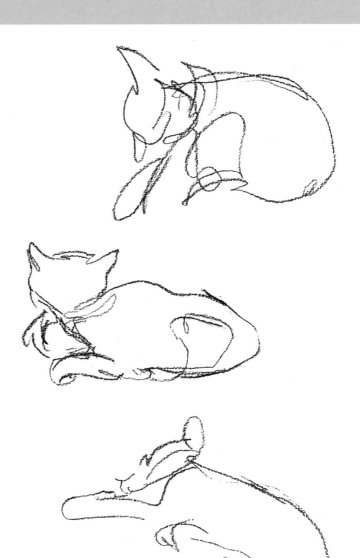

Sleeping pets make sweet models and give you a little bit more time to gather the information you need to create a recognizable drawing. Stick to quick, gestural studies, though . . . no more than one minute each!

LAB 4 A Day at the Zoo: Part I

Materials

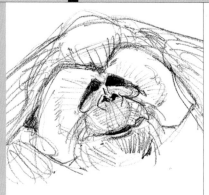

- your sketchbook, or a stack of white card stock and a clipboard
- mechanical pencil

"Someone told me it's all happening at the zoo."
—Paul Simon

PACK YOUR SKETCHBOOK AND PENCIL; we're going to the zoo! Drawing from life is always preferable to using photos, and the challenge of moving animals will sharpen your observation skills and hone your hand–eye coordination. In the next four pages, artist Sherrie York offers tips and suggestions on sketching live animals at the zoo.

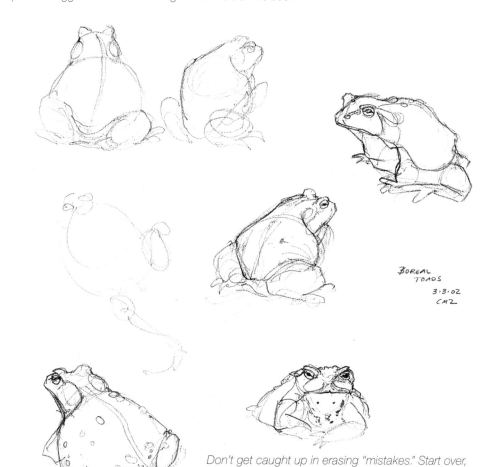

BOREAL
TOADS
3·3·02
CMZ

Don't get caught up in erasing "mistakes." Start over, restate, or draw a big X through the drawing, but don't stop moving your pencil.

Instructions

1. Read "Sherrie's Zoo Tips" and prepare yourself for your field trip.

2. Once there, pick your first exhibit and watch your subject for a while before settling in to draw. Get a sense of how active your subject is and how visible.

3. Gesture drawings are the key, especially in the beginning. (A gesture drawing is basically any drawing that emphasizes movement . . . a quick sketch of what your brain has already seen.) Sometimes all you can get is the curve of a spine or tilt of an ear, but that's okay.

4. Look for the underlying geometry of the subject: ovals, triangles, trapezoids. Block these in lightly and refine the shapes as you have more time.

5. Don't erase, start another! (Erasing will only break your focus.) If you've spent a few minutes on a drawing and the animal moves, don't despair. Start another drawing on the same page. Chances are your subject will go back to the same pose, or one similar enough that you can carry on.

6. When you start to tire, take a break and return to sketching after stretching your legs or getting something to eat.

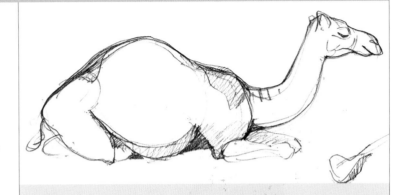

Sherrie's Zoo Tips

- Be comfortable. Not all zoos have convenient places for sitting in front of exhibits. Take a small, lightweight, portable camp stool along if you're not comfortable standing with your sketchbook.

- Don't take too much gear. One sketchbook, one pencil, and one sharpener are enough for a day at the zoo. (If you take a mechanical pencil, you don't even need the sharpener.) Colored pencils are nice to have, too, but not necessary. Take notes!

- Find out when the busy times are, and avoid them.

- Bad-weather days can be great to draw at the zoo. Crowds are smaller, and animals are often in indoor exhibits where you can see them better.

- People will try to talk to you as you work. If this is distracting, try wearing headphones. (They don't actually have to be on, but they can be a good deterrent to casual chatter.)

- Binder clips can help hold pages in place outside in the wind.

- Even though you're at the zoo, you're still often drawing outside. On a good weather day, remember a hat and sunscreen. And you will probably be more comfortable with off-white paper in your sketchbook, rather than bright white sheets.

- Have fun!

Artist Sherrie York's stack of sketchbooks contains hundreds of animal sketches from frequent zoo visits over the past fifteen years.

Materials

- sketchbook
- set of artist pencils
- kneaded rubber eraser
- pencil sharpener

Note: A day at the zoo is a great place to explore the traditional pencil. Take this opportunity to learn not only about animals but also the different pencil weights available to you.

"The idea is to get the pencil moving quickly."
—Bernard Malamud

IN A ZOO ENVIRONMENT, animals' movements are confined to a particular area and they often repeat actions. You can start several drawings on the same page, one for each stopping point, and then come back to each drawing as the subject engages in that behavior again.

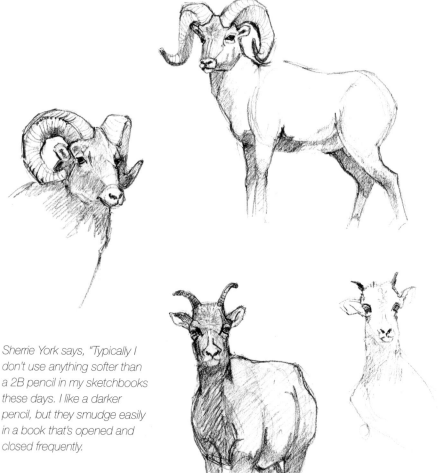

Sherrie York says, "Typically I don't use anything softer than a 2B pencil in my sketchbooks these days. I like a darker pencil, but they smudge easily in a book that's opened and closed frequently.

Sherrie's Pencil Tips

1. **Pencil gymnastics:** What can your pencil do? Spend some time just getting to know the way a pencil makes marks. Press hard. Drag it lightly across the page. Use the tip. Use the side. Try different weights of pencil. Try to smudge it. Try to erase it. Don't be afraid! It's just a pencil!

2. **Pencil weight:** Not confusing if you remember H = Hard and B = Black. A hard lead will make a lighter, finer line than a soft one. More H's = hard lead, lighter line. More B's = soft lead, blacker line.

3. **Softer pencils:** A soft pencil will lose its point faster than a hard one. Use this to your advantage! I like to do the details of my drawing with a fairly sharp point, but once the pencil lead gets wider, that's the time to do some shading and then sharpen again.

4. **Vary your line quality:** Vary the firmness of your strokes; press hard, and lighten up in the same line.

5. **Avoid erasing:** Don't be afraid to restate lines without erasing the ones that are already there. The energy of a moving animal is reflected in the overlaid changes.

Taking It Further

When home, go back into your sketches and add color with colored pencils, markers, watercolor, pastel, or your preferred medium.

- stack of 20 white index cards
- large black chisel-point marker

Right: *Because each of these drawings is done quickly, you can't consciously control the outcome of each one. You need to trust that your hand will do the job for you!*

> *"I like to employ a form of repetition, in which the same elements recur but in different and unexpected ways."* —Graham Nelson

IN THIS EXERCISE, you will draw one dog, one pose, but twenty times. By drawing the same animal multiple times, you will get subtle variations in facial expression and character. You will also experiment with line quality, using the chisel end of a large marker. (And why index cards? Sometimes working on "good" paper can inhibit us; a stack of plain white index cards takes all the pressure off.)

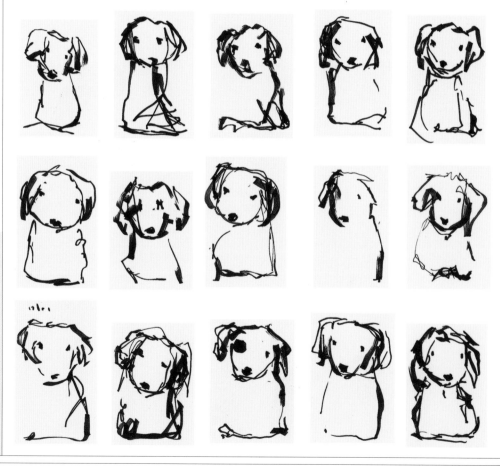

Instructions

1. Take a few moments to sketch out the basic outline or shape of a dog, and keep it in front of you as a general reference. (Since you are working with such a large marker on such small paper, details will need to be kept to a minimum.)

2. Draw your first dog, remembering to keep your hand as loose as possible. Turn your pen around as you draw so that you get both thick and thin lines. Don't worry whether you are doing it "right"— just experiment.

3. Now draw another one, and another. Keep drawing the same dog over and over, working quickly, until you tire of the exercise.

4. Take a five-minute break and begin again. You might try working a little slower than you had for the first batch—or a little faster— do what your intuition tells you.

5. You now have twenty dog drawings. Spread them out and spend some time examining the batch you have created. You can remove the "dogs" and pare your collection down to your favorites.

6. What is it about particular drawings that appeals to you? Just being more aware of what you like and don't like will move you one step closer to developing your own style.

This particular puppy became a favorite due to its backward glance and mischievous expression. The little mishap was created separately in watercolor, and both images were scanned and combined digitally.

Taking It Further

- Photocopy the grouping at 50 percent and paste the mosaic image into your journal.

- Scan a favorite into your computer and alter it digitally by adding color or dropping in a photographic background.

- Doodle it! The image below was created by photocopying a dog at 200 percent, and then applying the "Doodling on Steroids" assignment (Lab 33), while listening to "A Dog in Church" by Mark Twain.

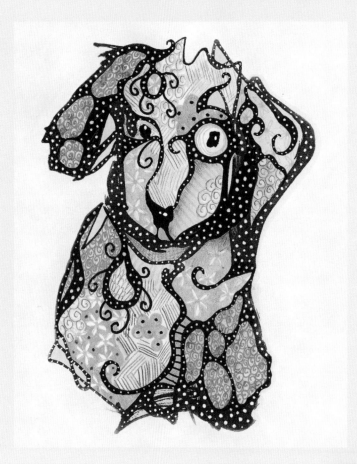

Materials

- photo references of monkey faces
- white card stock
- collection of four preselected drawing utensils (for example: a larger blue permanent marker, smaller pink and brown permanent markers, and a stick of red pastel)
- spray fixative (if using charcoal or pastel)

"Color is a dangerous thing. A little goes a long way."

—Mark English

TOO MANY CHOICES CAN BE OVERWHELMING and distract you from the task at hand: drawing! This can be especially true with color. In this exercise, you will draw a monkey's face, using only four colors that you preselect.

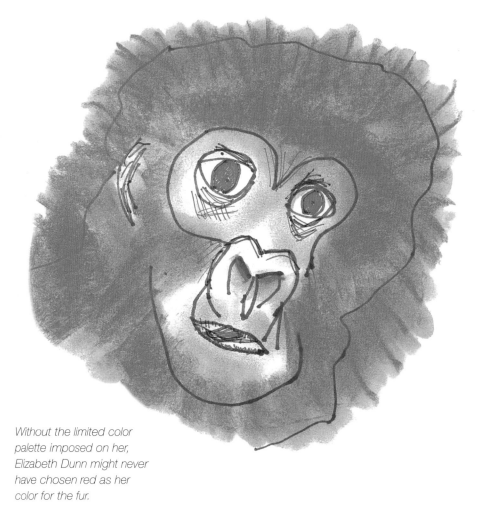

Without the limited color palette imposed on her, Elizabeth Dunn might never have chosen red as her color for the fur.

Instructions

1. Gather your references and select the monkey face you would like to draw. With your larger marker, draw the outline and main features of the face. Be sure to look at your reference more often that you look at your paper. Work fairly slowly in a contour-like fashion. (See Lab 25 for more on contour drawings.)

2. Add shading details with your smaller markers, referring to your reference to gather information. Use cross-hatching or scribbling. (If you have trouble seeing the darker areas in the photo, squint your eyes.)

3. Add pastel, either directly on the drawing for a bolder look, or rubbing it on with your finger for a softer look.

4. Look at your drawing and see if there is anything else you would like to add . . . a few extra hairs, maybe? A few more lines around the eyes? (At this last stage you can abandon the reference and look at the drawing only to see if it works for you.) Spray with fixative.

To make it more fun, create several preselected packets of color combinations and place in envelopes. Then, when you are ready to draw, pick one out randomly and commit to only using what you pick, however incongruous the colors might seem.

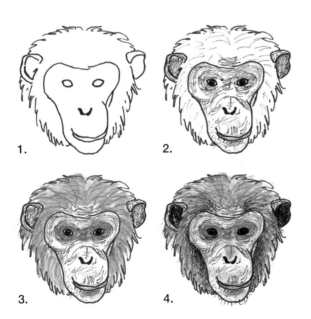

These four images show the progression of this particular drawing.

A Note about Color

When choosing colors, remember that complementary colors—colors opposite each other on the color wheel—always look good together: red and green, blue and orange, purple and yellow. If you find you are stuck or unsure about which color to use next, it might help to talk to yourself: "Okay, I have a lot of blues and greens in this piece. What should I add next? Oh, oranges and reds would work. Pink? A reddish brown?"

LAB 8 Imaginary Creatures

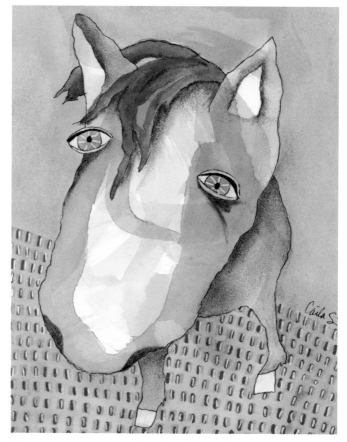

Materials

- several sheets of 5" × 7" (12.7 × 17. 8 cm) watercolor paper

- small watercolor set

- #12 round brush

- black Pigma Micron or similar pen (size 01)

- vine charcoal

"Logic will get you from A to B. Imagination will take you everywhere."

—Albert Einstein

IN THIS LAB, YOU WILL EXPLORE letting random paint marks "tell" you what to draw. This way of working can be very freeing, as it takes all the pressure off. (If the drawing fails, well, you probably weren't given anything viable to work with in the first place. Not your fault!)

Green Horse *was created by the author using watercolor, green permanent marker, white paint pen, and ink.*

Instructions

Note: You can work on several pieces simultaneously, if desired.

1. Using watered-down red watercolor, paint several random marks on your paper. Let dry.

2. Using blue watercolor, paint several more random marks on your paper. Let dry.

3. Using yellow watercolor, paint several more random marks on your paper. Let dry.

4. Now take time to really look at the abstract forms on your paper. Do you see a creature? A foot? A face? Try turning your paper 90 degrees clockwise. Keep turning your paper until something presents itself to you.

5. With your ink pen, start filling in the lines that form your creature. Remember to keep your lines fairly loose and sketchy. (Note: It's not necessary to see the entire animal at once. If you just see a ear or a nose, start with that. Then you can complete your animal by using your imagination, abandoning the painted lines.)

6. Once your animal is complete, go back in with layers of watercolor and charcoal to complete your painting.

Creatures Gallery

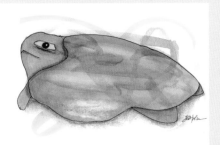

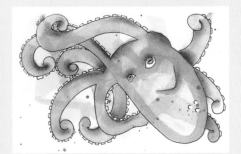

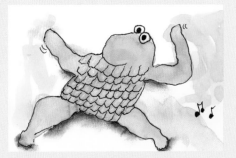

The turtle, octopus, and frog paintings are student samples by Jill Holmes, Brenda Shackleford, and Kay Hewitt, respectively.

Featured Artist

Katherine Dunn

Artist, mother to sheep, donkey dreamer, friend to weeds and old dogs

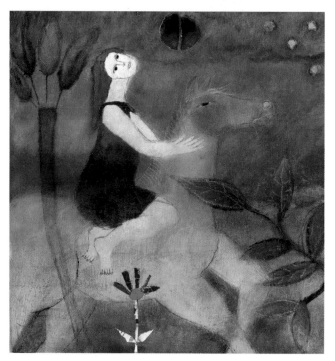

Horse Guiding Woman; *acrylic/mixed-media on wood*

ALTHOUGH SHE NOW LIVES on Apifera Farm in Oregon, Katherine Dunn was raised in the city and traveled and studied in Europe. "I love textures, fabrics, books, the shapes of buildings and the form of a shoe or face—I'm still inspired to paint those things—it's just that in the middle of any given project, a donkey might be braying in the background. And I love that." Katherine began her illustration career in 1996 when she was living in Minneapolis. Her work has evolved to a "naive elegant" style—a combinaton of traditional drawings/pastels/inks/fabrics, layered in a way that create textural, mystical pieces, but often whimsical ones, too.

Q and A

Q: *What is your drawing routine or practice?*
A: I tend to have multiple projects going on at once. I work intensely and then switch to other mediums, or even work on sewing folk dolls, or do paintings instead. I will sit with a pad, but generally it's more of a note-taking session when I capture the essence of something I'm feeling or seeing, and then I draw later.

Q: *Erasers or no erasers?*
A: Oh sure, why not? I love anything in a drawing that shows the process or energy of the hand. I am not a

perfectionist. I didn't stay inside the lines as a child. I think that not allowing myself to get attached to the outcome or to treat the art as a china doll, is important for me to keep it fluid. And you know, in commercial work, you can touch things up in a scan if they are really bothersome to an art director.

Q: *From life or your imagination?*

A: Both, but really more from my imagination, and heart. I think my work is more about emotional storytelling, than drawing a proper perspective or event. (Many do that very well, and I really admire them! They are draftsmen, I am not!) I think reality is a starting point for me, but then the idea flows from imagination and thoughts and a variety of experiences that entwine into my head and heart when I sit down to create.

Q: *How does drawing affect your mixed-media work?*
A: It all intertwines. I try not to separate the two anymore. I'm just telling a story, even if it's a tiny short story about a bird I saw. I do think traditional drawing—where you sit and look intently at something, and draw—is a wonderful focusing exercise. It teaches you to "look" more, and slow down. Not so much feel, but look, the way a scientist would look at a cell under a magnifying glass.

Q: *Why should anyone draw?*
A: Drawing is a tool to help you see. Maybe it can be looked at as being comparable to yoga. Yoga strengthens muscles, helps balance. Drawing is "seeing" yoga. It strengthens the eye muscles and balances one's insane mindless activities with focus, attention, calm.

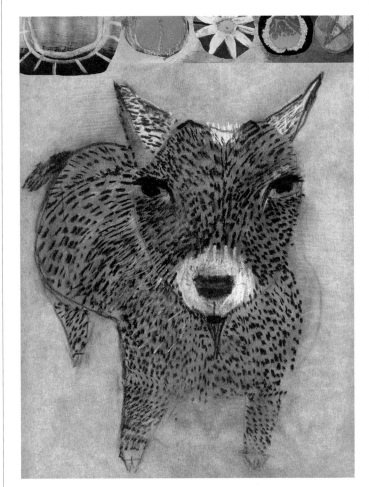

Goat in the Sun; *mixed-media/collage on paper*

Q: *Anything else?*
A: I'm just glad I grew up in a home with an architect father who had lots of books around. I learned to draw by mimicking artists I liked. It helped me become what I am, and I'm grateful for that.

Inspired by People

AT THE AGE OF THIRTY, I CHANGED CAREERS and started working as an assistant graphic designer in a field I loved: publishing. My favorite part of the job was working with the artists and illustrators. Eventually I got up the nerve to take a drawing class. My boss encouraged me to skip Beginning Drawing and take Figure Drawing instead. "If you can draw the figure, you can draw anything," she said. I took her advice and fell in love with drawing.

If we are to draw things we like, then it's very likely that our drawings will include people. There are few things more compelling than the human face, or more beautiful than the human figure.

Most of the exercises in this section involve drawing from a live model, which will include friends and family, fellow patrons, strangers, and paid models.

This figure drawing was drawn from a live model and created with red concentrated watercolor and an eyedropper. The drawing took less than a minute.

Wrong-Handed Portraits

- ¼ sheet white card stock
- black extra-fine-point permanent marker
- a friend

IN THIS LAB, YOU WILL DRAW a friend's face, using only a permanent marker and your non-dominant hand. This is the first exercise students do in nearly all of my workshops, whether for adults or children, and is designed to help you get over your fear of not making a "perfect" drawing. No erasing, not much control . . . these limitations practically guarantee imperfection, which is a good thing.

Instructions

1. Using your nondominant hand, start drawing your friend's face, looking at the face about 60 percent of the time and the paper about 40 percent of the time.
2. Talk to yourself. "The hair goes kind of like this, and the eyes are about this far apart."
3. Don't worry about your unsteady lines . . . this is just a practice exercise to start getting your hands and eyes to work together.

4. Remember to look at your friend's face more often than you look at your drawing.
5. After several minutes you will feel "done." (This is the time to stop . . . don't overwork!)
6. Draw every friend, neighbor, stranger, or family member you meet and add the drawings to your growing collection.

"True friends stab you in the front."

—Oscar Wilde

Above: *Resist the urge to apologize to your friend for making her look like a "monkey."*

Opposite page: *This impressive grouping was created by adult students in various 2009 mixed-media workshops.*

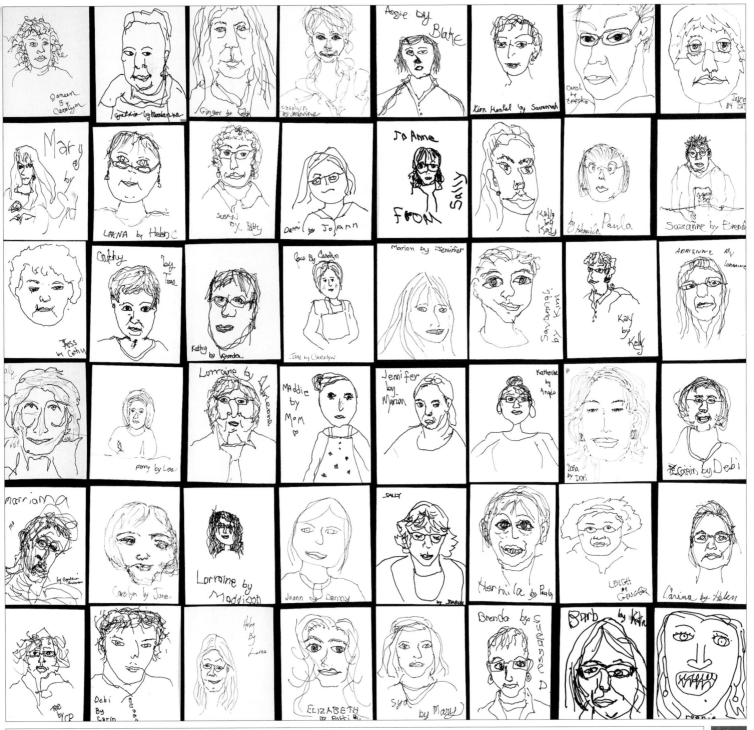

BRITISH ARTIST SARAH WILDE calls her modified blinds "direct-response drawings." They began as blind contours, but are drawn from a distance, focusing not on every nuance of contour but on the shape and form of her subject. In this assignment you will practice direct-response drawings while drawing live at a public place, such as a train station or a coffee shop.

- your sketchbook, or 5–7 sheets of card stock

- pen of your choice

"Coffee falls into the stomach . . . ideas begin to move, things remembered arrive at full gallop . . . the shafts of wit start up like sharpshooters, similes arise, the paper is covered with ink. . . ."

—Honoré de Balzac

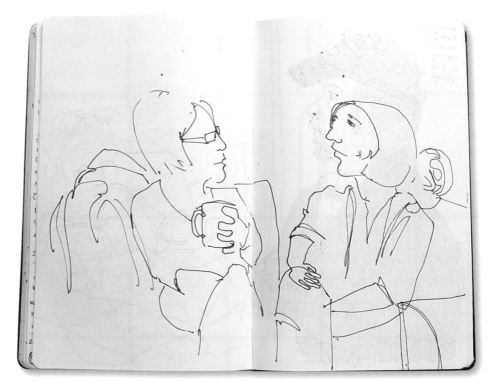

Drawing people in restaurants, waiting rooms, and train stations provides models that are occupied and so relaxed and natural. All the drawings on these two pages by Sarah Wilde.

Instructions

1. Begin by getting yourself a cup of coffee or tea and selecting a nice corner seat—somewhere where people can't come and peer over your shoulder (if this will distract you).

2. Take a good look around; the most important thing is to slow down and feel comfortable.

3. Once you find someone who looks interesting—either a person is sitting in an interesting way or some dynamic among members of a group catches your eye—get out your sketchbook and pen.

4. Without looking at your paper, start at the top of the head and work slowly down, looking for the angles of the shape of the head and the tilt on the neck.

5. When you get to the collar, you need to make a decision about whether to complete the head now or carry on down the back or shoulder; it's your choice, depending on the position of your model or whatever feels right at that moment.

6. As you continue down the body, aim to draw the shapes and angles that you are actually seeing. It might help not to name things. Instead of thinking, "Oh, an elbow," try instead to think about how much the line curves before it begins to straighten out again.

7. Continue your drawing to include tables, chairs, cups, and plates as you arrive at them.

8. Once you have completed your blind drawing, you can go back in and add facial or other details (while looking at your paper).

Sarah's Café-Drawing Tips

- Café drawing is best done in chain cafés; generally I can sit in a Starbucks or Borders for hours and not be disturbed.

- Do four or five drawings in a session.

- Go slowly except for hands (because people move their hands a lot).

- Use a continuous line in places to help with the spatial relationships—this also gives the drawing a flow that is visually appealing.

- Suggest creases in fabric while drawing blind, but add other details and patterns afterward.

- Direct-response drawings are both process and product. Long term, they can improve overall drawing immensely; they also prove fertile ground for ideas for other things.

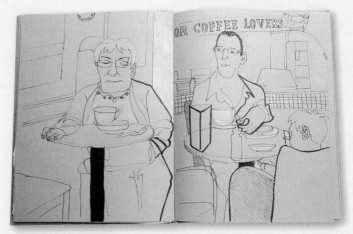

"If there is any lettering by the person I will include it, as typography fascinates me almost as much as people. I always draw this without looking," says Sarah.

Cheater Blinds

Materials

- family photos for reference
- several pieces of white card stock
- black fine-point permanent marker
- black extra-fine-point permanent marker

"The moment you cheat for the sake of beauty, you know you're an artist."

—David Hockney

USING BLACK AND WHITE ONLY, draw from family photographs, using a modified blind-contour drawing technique. The distortion that occurs when you draw without looking at your paper can provide surprisingly appealing results. Even though you are not aiming for a realistic rendering here, you will be surprised at how much your drawing will look like your subject.

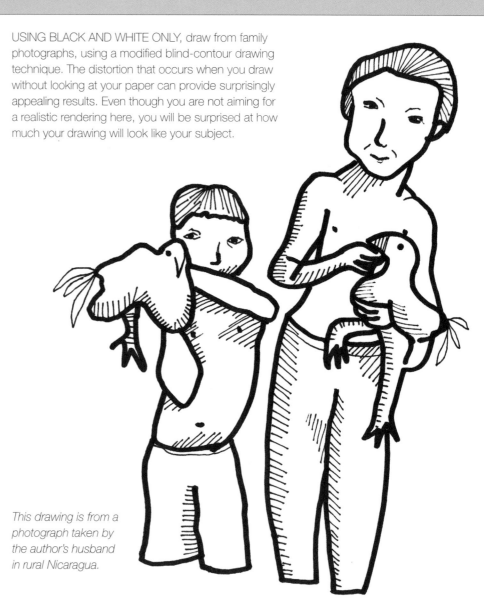

This drawing is from a photograph taken by the author's husband in rural Nicaragua.

Instructions

1. Cull through your vacation photos, picking some that would make interesting drawing subjects.

2. Without looking at your paper, start drawing your figure or object with your larger marker. Work slowly and concentrate on your reference; try to have your eye and hand move at the same speed.

3. After a minute or so, you can cheat by looking at your paper to make sure your drawing is not overlapping itself too much. Continue the outline, again looking mostly at your reference, but perhaps with one more cheater look to finish it off.

4. Add detailing in a cross-hatch fashion with your smaller marker. You are free to look at your paper as much as you like at this point, though you should continue to check your reference periodically.

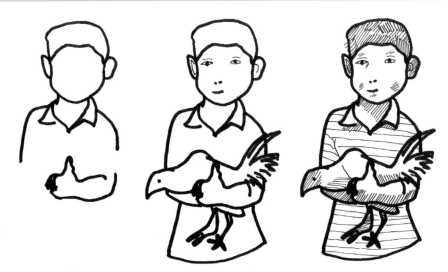

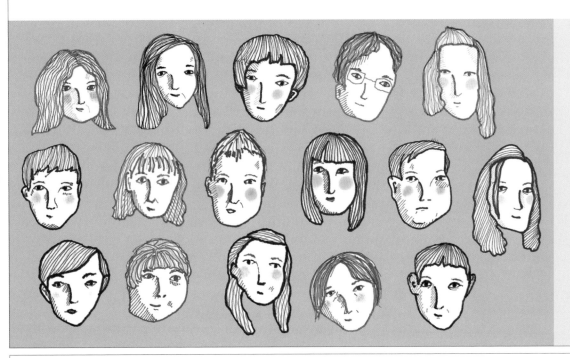

Cheater Blinds in Technicolor!

These faces were drawn from a seventh grade yearbook using colored markers and pastel. Even though the cheater blind method was used, many of these drawings look very much like the person in question.

For Your Eyes Only

Materials

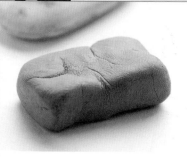

- various papers of your choice, cut to 5" × 7" (12.7 × 17.8 cm) sheets

- pencil

- kneaded rubber eraser

- black ink pen (size 01)

- vine charcoal

- small set of colored pencils

"There is a road from the eye to the heart that does not go through the intellect."

—G.K. Chesterton

PRACTICING DRAWING ACCURATELY IS IMPORTANT, even if you have no intention of persuing realism in your artwork. (The cliché "You need to know the rules before you break them" has some truth in it.) In this lab, you will draw the human eye as accurately as possible four times, using four different mediums: pencil, pen and ink, charcoal, and colored pencil.

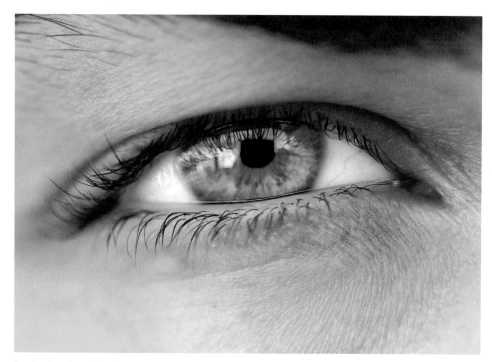

Look closely at this photograph by Steve Sonheim. Notice the flecks in the irises, the lengths of the eyelashes, the crease over the eye. Use this photo as a reference when doing this assignment.

Instructions

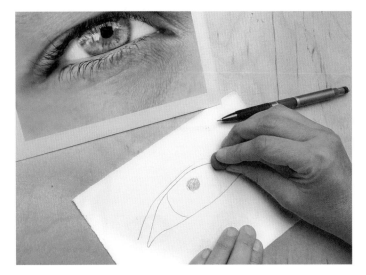

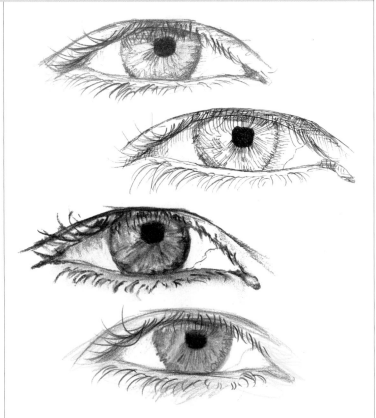

1. With your pencil, lightly sketch four eyes on four pieces of paper. Try to keep them about the same size and do your best to make them as accurate as possible.

2. Take your time doing these drawings, especially in the beginning when you are trying to get the proportions right. Keep that eraser handy!

3. Now render one eye more fully in pencil, building up shading and value with cross-hatching and lines, and using your eraser to pull out highlights. You should refer to the reference to the left throughout the entire drawing process.

4. Repeat step three with pen and ink, charcoal, and colored pencils.

5. This is your chance to play around with these different mediums. For now, try to just have fun and let your intuition be your guide when working with these tools. Today you are getting a sense of what medium you respond to the most; later you can do more research on the "correct" usage of your preferred medium (though nothing is better than your just picking up the tool and using it).

Taking It Further

After you have practiced drawing eyes realistically, your more stylized eyes will have more authenticity.

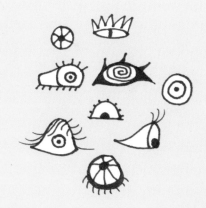

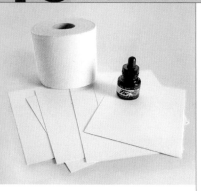

Materials

- 140 pound (64 kg) hot-press watercolor paper, cut down to 5" × 7" (12.7 × 17.8 cm) sheets
- black FW acrylic ink
- roll of toilet paper

"Blessed are those who see beautiful things in humble places where other people see nothing."

—Camille Pissarro

DRAW A SERIES OF FACES from a photo reference, using only an eyedropper and toilet paper. Find an interesting face image from a newspaper or magazine. Here, a fashion ad was used to inspire.

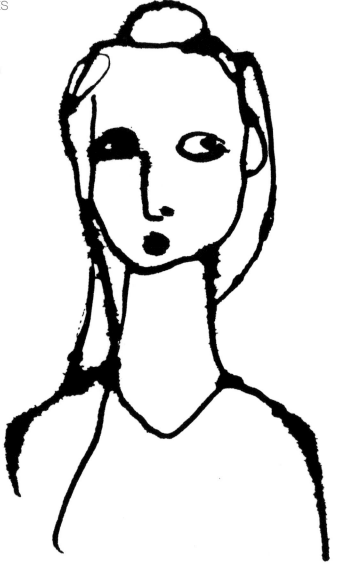

This rendering stands on its own with no need to embellish further.

Instructions

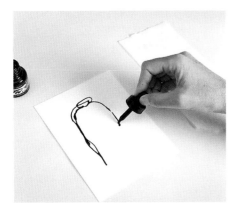

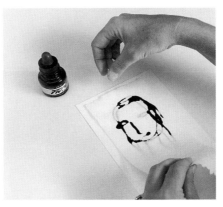

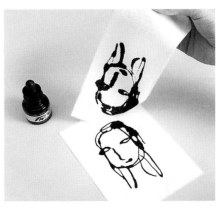

1. Load the eyedropper and squeeze the ink out gently onto your paper. Draw only the basics: face shape, hair, eyes, nose, mouth, neck.

2. Quickly take a piece of toilet paper and lay it on top of your drawing. The ink will soak into the toilet paper and spread out underneath.

3. Quickly lift the toilet paper off and set aside. Let dry completely.

Taking It Further

Working this way will probably provide many "disasters." Once the ink has dried, you can go back into the pieces you don't like, and see if you can pull them together with markers, watercolor, colored pencil, charcoal, or collage additions.

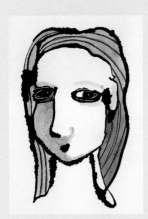

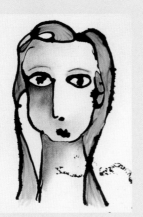

Far left: Pencil, white gel pen, and a light wash of black watercolor were added to save this one from being too "cutesy."

Center: Light blue Copic marker and vine charcoal added personality to this version. Notice that the black ink was reconstituted by the Copic marker; it was turned into an advantage by making streaks in the hair.

Left: Watercolor, colored pencil, Copic markers, and a white gel pen were added to this face, which at first seemed to lack character.

Life Drawing: Short Poses

Materials

- pad of drawing paper, 11" × 14" (27.9 × 35.6 cm) or larger

- vine charcoal or charcoal pencil

- optional: portable easel

"Nudes are the greatest to paint. Everything you can find in a landscape or a still life or anything else is there: darkness and light, charac-ter dimension, texture."

—John Hurt

THERE IS A LONG TRADITION of drawing the human form; figure drawing is, in fact, the traditional cornerstone of formal art training. If you really want to improve all aspects of your drawing, you should give life drawing a try!

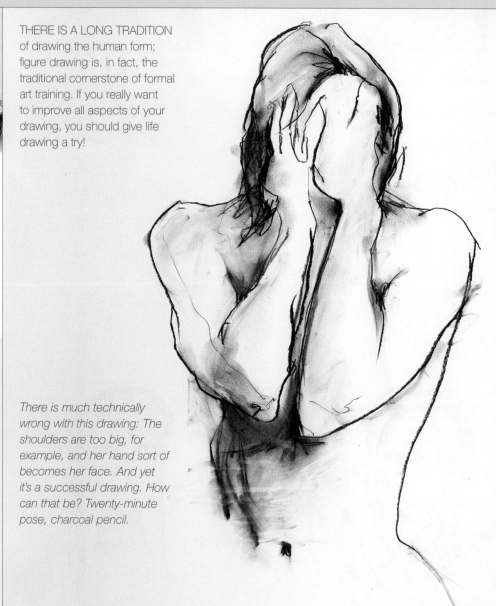

There is much technically wrong with this drawing: The shoulders are too big, for example, and her hand sort of becomes her face. And yet it's a successful drawing. How can that be? Twenty-minute pose, charcoal pencil.

Instructions

1. Find a life drawing group in your area. Try universities, art leagues, or individual groups, who pool their resources and hire a model.

2. Arrive a little early so that you can get comfortable before the model and other students arrive.

3. A life drawing session will typically begin with a series of quick poses (30 to 60 seconds each). Use this time to do a series of gesture drawings (for more on gesture drawings, see Lab 3).

4. As poses get even longer (between 5 and 20 minutes), you should still spend the first minute or so getting the form down with a quick gesture; then use the remaining time to fill out your figure with line and shading.

5. During breaks, walk around and see what other artists are doing. Usually in a friendly group with a spirit of learning, you will rarely find someone who is shy about showing his or her drawings. Talk to other artists and see if they can point you in a direction you hadn't thought of before.

6. Careful observation is the foundation of all drawing, so observe!

A Note on Nudity

If this is new, you might feel nervous or slightly uncomfortable about this particular aspect—I did! But I promise that once you start drawing, you will forget that the model is naked. Drawing the figure from life is a challenge, and you will need to focus all your attention on lines, angles, curves, shading, and proportions.

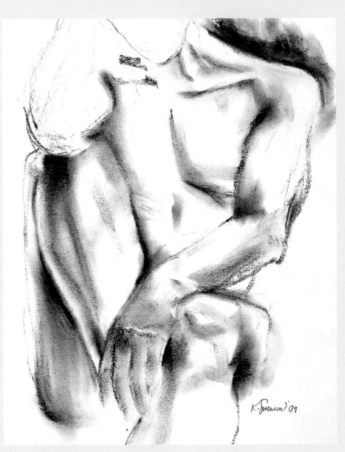

This charcoal drawing by Karine Swenson took about fifteen to twenty minutes.

Far left: Gesture drawing with charcoal pencil.

Left: As poses lengthen to one or two minutes, try switching gears for a few drawings and record just the weight and form of the figure, starting from the inside of the form. No lines!

Life Drawing: Long Poses

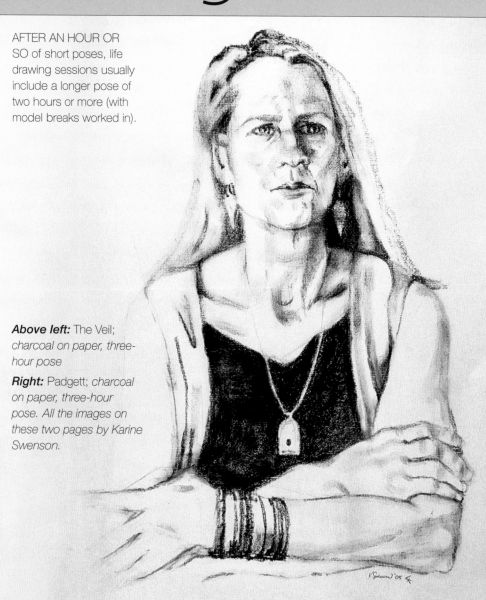

AFTER AN HOUR OR SO of short poses, life drawing sessions usually include a longer pose of two hours or more (with model breaks worked in).

- paper, canvas, or other substrate of your choice
- charcoal, pastels, or paints of your choice

"Drawing is like studying Greek and piano—you can't speak or play in your conscious, which is clumsy. You must get it into your subconscious, which is graceful. But that takes time."

—Robert Beverly Hale

Above left: The Veil; *charcoal on paper, three-hour pose*

Right: Padgett; *charcoal on paper, three-hour pose. All the images on these two pages by Karine Swenson.*

Instructions

1. Once your model has settled into her pose, take the time to really look at her position, and try to plan mentally how she is going to fit on your page. If you are having trouble with the pose, move to a different spot in the room, if possible. Remember, this is your drawing/painting, and you have the ability to make changes now so you are satisfied before you even start!

2. Lightly block in the entire figure. Remember, you have a long time, so take the first ten minutes or so to make sure you are satisfied with the placement of the figure on the page.

3. Next, spend time getting your proportions as accurate as possible, working on the entire figure at once. For example, don't spend the first hour working only on the face, thinking you'll draw the rest later. The drawing should be at a "finished" stage at every step.

4. Continue to build up shading and details with pastel or paint.

5. This might be the first time in a long time that you have the opportunity to really slow down and focus. You have ample time to draw your model . . . take time often to stand back from your drawing or painting to get that necessary perspective.

Karine's Life Drawing Thoughts

- I prefer the intensity of painting or drawing with the person right there in front of me. There is so much communicated without words: Personality traits can be discerned by the tilt of a head, twist of the body, or even the intensity of the gaze.

- There is only a certain amount of time a person can sit still, so urgency forces me to focus on the most crucial features. I find myself asking, "What really characterizes this person?"

- A portrait really isn't complete without at least one hand. I love hands, and what they say about a person.

- When drawing the figure from life, don't forget to breathe. It seems basic, but you would be surprised what paying attention to your breathing will do!

- If you aren't getting the results you want, change something. Draw with your other hand, draw bigger or smaller, or draw with other mediums.

- Keep at it! If there is something you are having trouble with, focus on that. For example, I was having trouble with hands, so I drew only hands for about four months.

- Make it fun. If you take it too seriously, the art will suffer (and so will you!).

- Don't forget to look and learn from the drawings of old masters.

- I am not really interested in the human form as a symbol, or a generic representation of who we are. I am interested in the individual, and what makes each person unique.

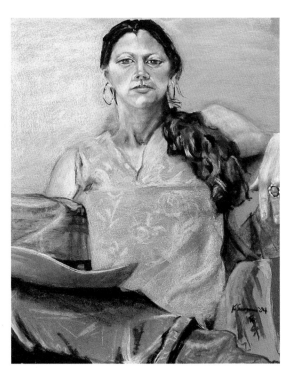

The Cowgirl; *pastel on paper, three-hour pose*

100 Faces Project

- a large stack of 4" × 5" (10.2 × 12.7 cm) sheets of paper of your choice (can be white card stock, watercolor paper, graph paper, charcoal paper, etc.). You can get started with twenty or so, then add to them as you run out.

- drawing and painting tools of your choice

"It is the common wonder of all men, how among so many millions of faces, there should be none alike."

—Thomas Browne

THIS IS A PROJECT THAT YOU WILL BUILD over time, weeks or months even, depending on your schedule. Even if you just do one face in one sitting, that's fine. Number each drawing on the back and keep adding to your collection until you reach one hundred faces. You will draw from life, from photos, and from your imagination.

The author's in-process mess

Instructions

1. Gather your materials around you and just start. Draw faces from life. You can draw your self-portrait by looking at a mirror, draw your family and friends, or draw strangers. Try contours, blind contours, wrong-handed drawings, charcoal, and scribbly drawings.

2. Draw faces from photo references: magazines, family photos, the television set, your computer, and so on. Try one-liners, chisel-point sketches, pencil sketches, and eyedropper drawings.

3. Now draw some faces from your imagination. Just pick your medium, start drawing, and see what happens. Try applying the "Picasso Dogs" exercise (Lab 19) to a human face, or start with a collaged eye and build your drawing around it.

4. Most of all, just remember to experiment and have fun . . . some faces you will like more than others. That's okay! Not every drawing is a winner. Some are just average, and some downright ugly. (But like the humans they represent, each is beautiful in its own way, and has something to teach you.)

5. When you finish a face, sign and number the back (1/100, 2/100, etc.).

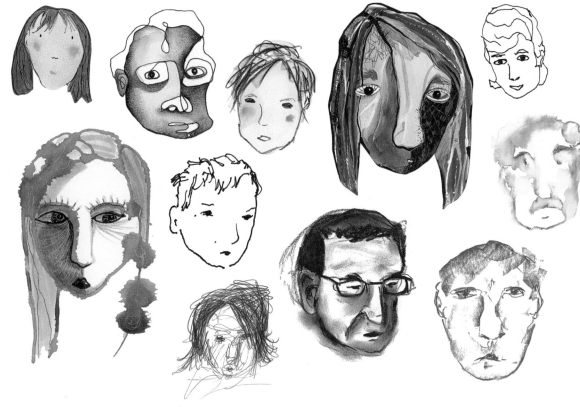

Try to approach this project in as many different ways as possible. By completing it over a period of time, you will find that some days you feel like working one way, and some days another. Do what feels best on any particular day.

Inspired by
Famous Artists

WE ALL LONG TO HAVE A STYLE that is fully our own. We want to find our voice and develop a hallmark look that is unique. But how do we get there?

One artist likened the process to a sausage grinder . . . all of your experiences, interests, tastes, and influences will be ground up, and out will come your art, your style. Try not to think about it too much and just start making lots of art!

One ingredient to throw into your sausage grinder is your interest in the work of other artists. In his later years Picasso did a series of paintings based on the works of Rembrandt; Rembrandt himself was deeply influenced by sixteenth-century Venetian painting, especially Titian; Titian was trained in the studio of Giovanni Bellini; and so on.

In this unit we will do exercises based on the art of Leonardo da Vinci, Pablo Picasso, Joan Miró, Paul Klee, Amedeo Modigliani, and Dr. Seuss.

Opposite page: "Dog Fight" *was created by repeating the* "Picasso Dogs" *steps (Lab 19) five or six times, then finishing with markers and colored pencils.*

UNIT 3

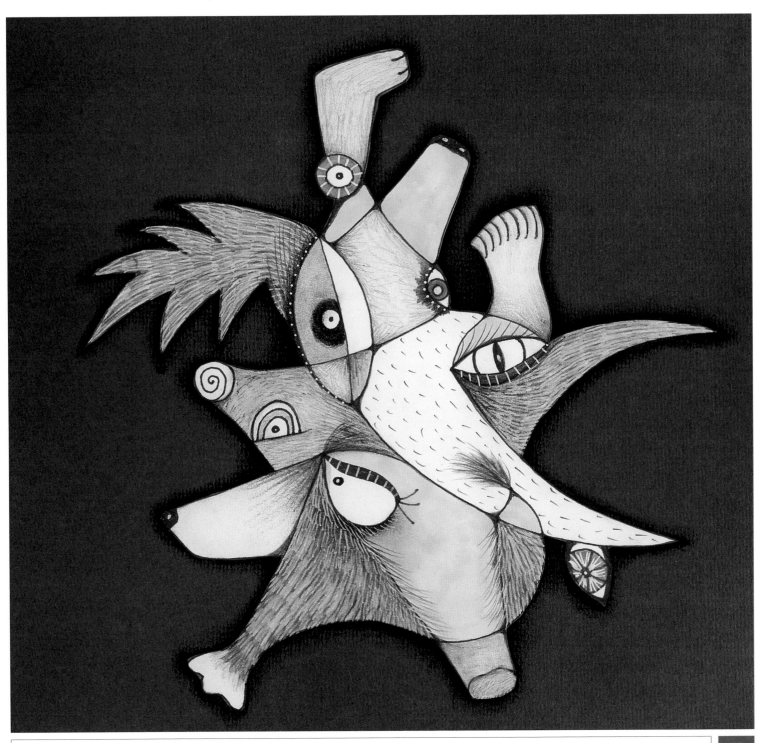

- sheet of tracing paper
- mechanical pencil

"If one knows how to copy, one knows how to do."

—Leonardo da Vinci

TRACING HAS A BAD RAP, and yet it can be a helpful tool when done in tandem with other drawing exercises. Today you will trace Leonardo da Vinci's Angel for the Madonna on the Rocks. Why? Your mind will subconsciously remember the image, giving you a greater reserve of visual knowledge to draw from.

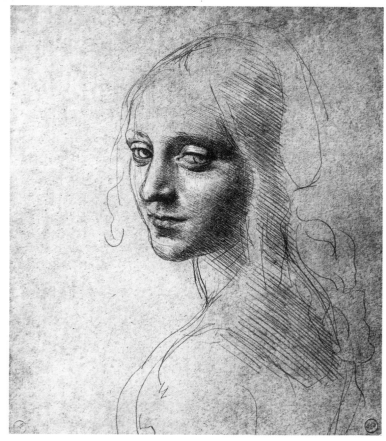

Leonardo da Vinci, Angel for the Madonna of the Rocks, ca. 1483–1485. Metal point heightened with white on prepared paper.

Instructions

1. Make a photocopy of Leonardo's drawing, left, at 200 percent. Place your tracing paper on top of the drawing.

2. With one hand holding the papers steady, start tracing. Try to be as true to Leonardo's original lines as possible.

3. You can lift your tracing paper periodically to clarify sections before you draw.

4. When finished, set your drawing next to the reference. Look closely, and add anything at this point that might make the drawing more complete (you are no longer tracing, but drawing and making decisions to complete the drawing independently).

5. Repeat this exercise periodically with other old masters' work that you admire.

About Leonardo da Vinci

Leonardo da Vinci is widely considered one of the greatest painters of all time. Although only a small number of paintings survive, you can view numerous drawings at www.drawingsofleonardo.org.

Taking It Further

Find an Old Master drawing that you like and try to reproduce it as closely as possible (without tracing this time). In addition to those of Leonardo, try copying the drawings of Michelangelo, Honoré Daumier, Eugène Delacroix, or Rembrandt. This is a master copy of *Wild Horse* by Delacroix.

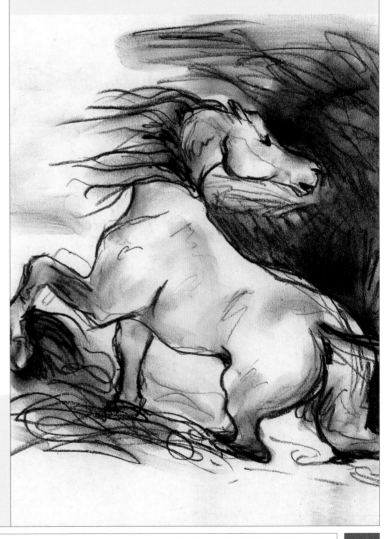

One-Liners

- white card stock, or your sketchbook

- black permanent marker

"The essence of drawing is the line exploring space."

—Andy Goldsworthy

MANY OF THE MODERN ARTISTS explored one-liners as a way of playing with line. In this lab, you will create a series of drawings made without lifting your pen. These are great sketchbook exercises or quick drawings to do while waiting at the doctor's office . . . you can also use one-liners as the framework for more developed pieces.

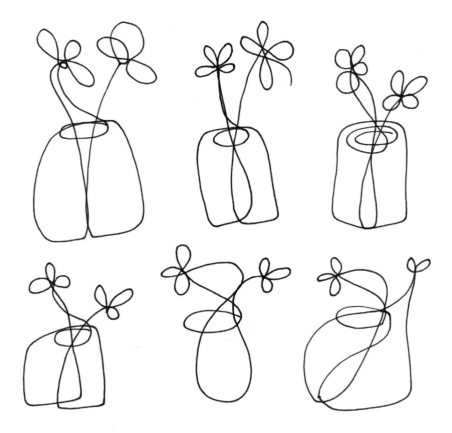

Notice the subtle variations in each of these drawings, even though the artist endeavored to repeat the same design each time. Once you find a one-line drawing that you really like, you can render it several more times until you get one that "hits it."

Instructions

1. Choose one of the subjects in the sidebar below and draw it from memory, using one line only. Do not lift your pen from the paper.

2. Try not to think too much, but just let the pen flow over the paper.

3. Remember it should look like one line . . . you should be able to follow the path from beginning to end with your eyes. Think loops!

4. Repeat this subject two or three more times, then move on to a second subject.

5. Repeat until you have drawn five or six items in this manner.

6. Now look at your drawings. Is there one that you like more than the others? Are there ones that surprised you?

Subject Suggestions

vase of flowers

bicycle

car

guitar

elephant

cat

human face

lightbulb

toilet

horse

house

tree

Elephant by Blake Greene

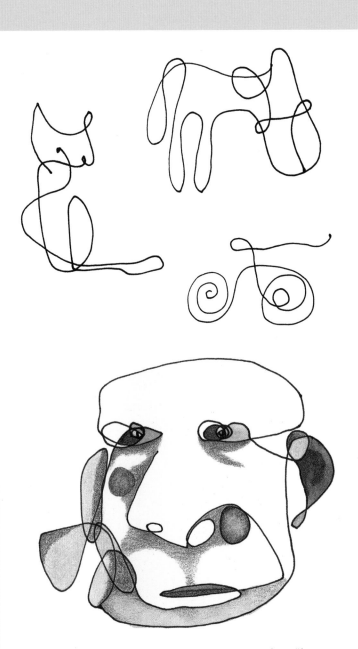

You can apply the one-line technique to drawings from life or photographic reference as well.

Materials

- 140 pound hot-press water-color paper, cut down to 5" × 7" (12.7 × 17.8 cm) or 6" (15.2 cm)-square pieces

- colored extra-fine-point permanent marker

- several Copic markers

- small set of colored pencils

"I paint objects as I think them, not as I see them."

—Pablo Picasso

CREATE YOUR OWN ABSTRACTED DOGS reminiscent of the style of Pablo Picasso. This lab has verbal instructions only, as you want to have as little visual input as possible so that you will come up with your own, unique version. Remember that the result is supposed to be slightly strange. Just try to relax and have fun with the steps.

Instructions

1. With a fine-point permanent marker, draw an eye anywhere on the paper. Turn your paper 90 degrees clockwise.

2. Draw a second, different eye, several times larger than the first eye. Turn your paper 90 degrees clockwise.

3. Draw a nose or snout. Turn your paper 90 degrees clockwise.

4. Draw a leg or paw. Turn your paper 90 degrees clockwise.

5. Draw a tail. Turn your paper 90 degrees clockwise.

6. Connect the elements together with straight and curved lines. Don't worry too much at this stage; just connect the pieces together and stop when it feels right.

7. Finish with markers and colored pencils.

Taking It Further

In Conrad Nelson's expressive interpretation, she used pencil for the drawing portion, and then completed her painting with water-colors and charcoal.

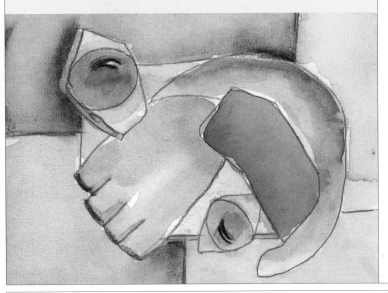

About Picasso

Pablo Picasso is one of the best known and most influential artists of the twentieth century, and co-founder, with Georges Braque, of the Cubist movement. You can view an incredible 17,209 works at the Online Picasso Project (www.picasso.csdl.tamu.edu/picasso/).

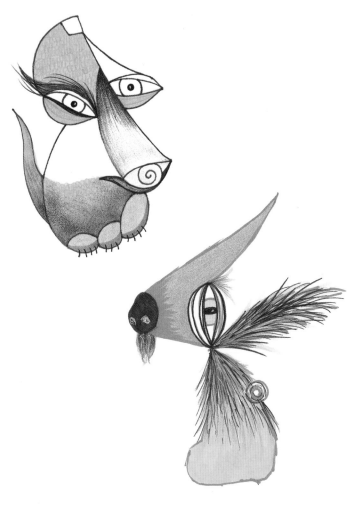

Miró Abstract

- 8" × 10" (20.3 × 25.4 cm) sheet watercolor paper
- pencil
- kneaded rubber eraser
- black ultrafine-point permanent marker
- blue, red, and yellow markers, or colored pencils

"In my pictures there are tiny forms in vast empty spaces. Empty space, empty horizons, empty plains, everything that is stripped has always impressed me."

—Joan Miró

TODAY WE WILL TAKE INSPIRATION from the organic forms, flattened picture frames, and bold lines of Spanish artist Joan Miró.

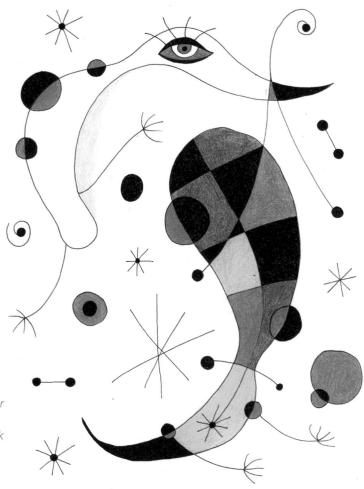

You may find this exercise to be harder than it looks; sometimes things that look the simplest are the most complicated!

Instructions

1. Take some time to familiarize yourself with the art of Miró, especially works from the late 1930s and early 1940s.

2. With your pencil, lightly block in a series "Miró-esque" elements. You can create your own language of symbols while you are researching Miró's art, or you can draw from the images on this page. Your goal is to fill the entire page, and try to make every element relate to, or orbit, another.

3. Stick with it. Just relax and keep working your design until you are satisfied. (Keep your eraser close at hand—you'll need it!)

4. Go over your pencil lines with your black marker. Once the ink has had time to dry, erase the pencil lines, if desired.

5. Color your design with markers, colored pencils, or the mediums of your choice, again taking a cue from Miró and limiting your color palette to mostly primary colors (red, yellow, blue).

About Miró

Spanish artist Joan Miró (1893–1982) was a painter, sculptor, and ceramist who has been characterized as a surrealist, though he would have most likely rejected such a label. See www.abcgallery.com/M/miro/miro.html for a catalog of his works.

Taking It Further

Consider approaching your pieces as if the artist were right there, collaborating with you. Jill Berry's piece, *Miró and Me,* is a "conversation with Miró about being an artist and, in particular, two artists fighting," she writes. "My two artists are the graphic and the illustrative, and they just won't get married. Miró and I tried to marry them here." Acrylic paint and ink on paper.

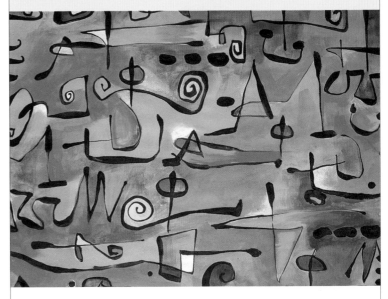

Klee Transfer Paintings

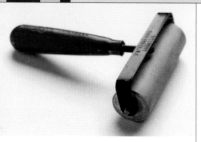

- sheet of carbon paper
- several sheets of water-color paper, 8" × 10" (20.3 × 25.4 cm) or smaller
- tracing paper
- black acrylic paint
- brayer
- watercolors or colored pencils
- pencil

"He has found his style when he cannot do otherwise." —Paul Klee

ARTIST PAUL KLEE invented a technique whereby he created highly expressive lines by transferring black oil paint onto his paper with a pencil. The unique line quality can be replicated somewhat with the following two transfer techniques.

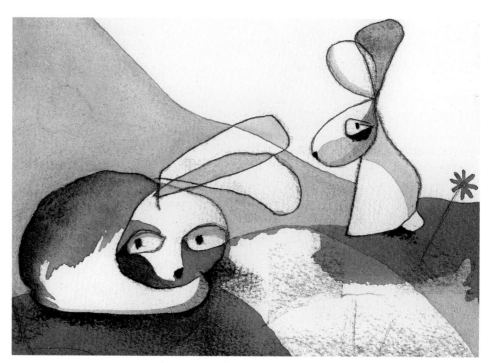

This rabbit drawing was made using the carbon paper–transfer method, then colored with watercolor and glitter paint.

Instructions

Carbon Paper–Transfer Method

1. Place the carbon paper, ink side down, onto your watercolor paper.

2. Using your fingernail, draw the image directly on the carbon paper. (If you have no fingernails, use a ring, the tops of your nails, etc. Force yourself to figure it out!)

3. You won't be able to see much of what you are drawing, but the overlapping lines and "mistakes" will add character to your piece.

4. Add color with watercolors, colored pencils, or your preferred medium.

Acrylic and Brayer-Transfer Method

1. On your tracing paper, draw the image you would like to transfer. Turn the paper over.

2. With your brayer, roll a thin layer of black acrylic paint onto the back side of the tracing paper.

3. While still wet, gently lay paint side down onto your watercolor paper. Trace your drawing with a pencil.

4. Lift off one corner of the tracing paper and see if it is transferring and determine if you are happy with the result. If not, you can gently place the paper back down, draw more lines, or rub your hand over the drawing to create random textures.

5. Quickly pull apart the watercolor and tracing papers. Let dry completely before applying color.

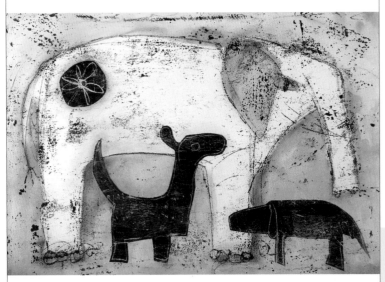

The acrylic and brayer transfer method was used to create the textured lines in this piece, with watercolor and collage added later. (The smaller animals are the actual acrylic-brayered tissue paper throwaways from another drawing.)

About Klee

Swiss-born painter Paul Klee was born in 1879 and defies easy categorization. His highly personal works were influenced by expressionism, cubism, surrealism, and even children's art. See his works at www.paulkleezentrum.ch/ww/en/pub/web_root.cfm.

Modigliani Parent Portraits

- 5" × 7" (12.7 × 17.8 cm) sheet of watercolor paper

- mechanical pencil

- set of watercolors

- #12 round brush

"Happiness is an angel with a serious face."

—Amedeo Modigliani

CREATE A PORTRAIT of one or both of your parents in the style of Amedeo Modigliani.

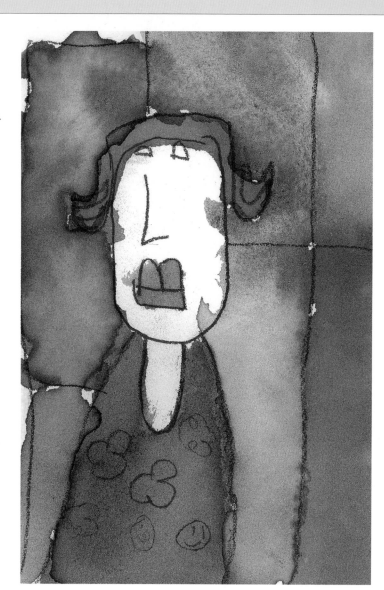

This beautiful rendering by Kayla Gobin was created when she was seven years old. Notice that she paints outside of her lines a bit, and that it actually adds personality to the piece.

Instructions

 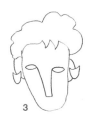

1. Beginning with a pencil, draw a U-shaped curved line in the middle of your paper.

2. Draw some hair, thinking of what your mother or father's hair looks like.

3. Draw almond-shaped eyes and an L-shaped or U-shaped nose.

4. Draw a mouth.

5. Draw two lines for the neck. (If you are close to the bottom of the page, go ahead and extend the lines off the page.) Add shoulders and a collar, if desired.

6. Add several lines in the background to place your figure in an environment. You do not need to add detail here; the lines are there only to suggest windows, doors, and the like.

7. Paint with watercolors, remembering to use lots of water and work in layers.

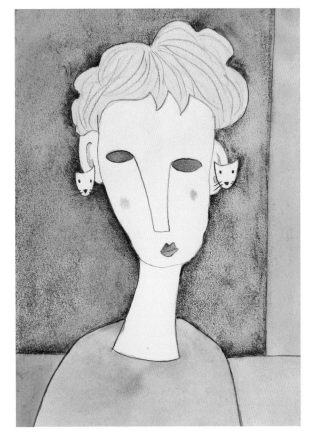

This rendering of the author's mother is complete with her trademark cat earrings.

About Modigliani

Italian artist Amedeo Modigliani's (1884–1920) unique portraits are characterized by flat, masklike faces, almond-shaped eyes, and overlong necks. His career was shortened by his premature death in 1920. See his paintings and sculptures at www.modigliani-foundation.org/.

Your Inner Dr. Seuss

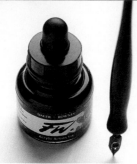

- Dr. Seuss books

- several sheets of white card stock, or your sketchbook

- 8" × 15" (20.3 × 38.1 cm) sheet watercolor paper

- pencil

- kneaded rubber eraser

- nib pen

- black acrylic ink

- watercolors, colored pencils, etc.

"You are you. Now, isn't that pleasant?"

—Dr. Seuss

HOW DID DR. SEUSS GET HIS IDEAS? His stock answer: "In a little town near Zybliknov, where I spend an occasional weekend." In this lab, we will emulate this delightfully, nonsensical artist and create a neighborhood in Zybliknov, "Dr. Seuss Style."

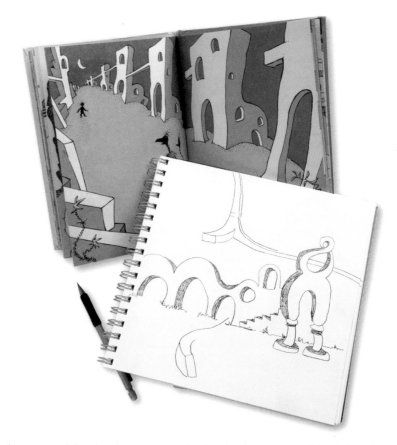

Whether you work in a book or on separate sheets of paper, your "sketchbook" should be the place where you feel free to make mistakes and work out ideas. Be aware of how your body is feeling; if you feel tense, get up and walk around the block, then come back to it.

Instructions

1. Go to the library and spend some time just flipping through children's books by Dr. Suess as a refresher to his style and humor. Pay particular attention to the almost droopy way he rendered stairways, arches, buildings, and other structures.

2. With your sketchbook and pencil, start drawing structures that are inspired by Seuss's work. Do not copy his work directly, but use his drawings as jumping-off points for your own creations.

3. Now switch to your watercolor paper. Lightly block in houses, stairwells, and other structures with your pencil. Your eraser might come in handy at this step.

4. Next, trace your pencil lines using a nib pen and ink. (If you haven't used a nib pen before, you might find it to be a challenge to get the lines even. This is a good thing! If you go back and look at Seuss's line work, you will see that his lines are varied in weight. Try to mimic his line quality as much as possible.)

About Dr. Seuss

Theodor Seuss Geisel (a.k.a. Dr. Seuss) began his career as a political cartoonist but is best known for his sixty-plus children's books, published starting in the 1950s until his death in 1991. Dr. Seuss's Seussville: www.seussville.com

5. Once your outline has dried, color in with watercolors or the medium of your choice.

Below: I'm not as comfortable drawing buildings as I am people and animals . . . perhaps it is because I feel there is more "give" with the live subjects. Dr. Seuss gives us the permission to draw buildings with less-than-straight lines. Hats off to Dr. Seuss! (But it does beg the question: "Why do we need permission in the first place?")

Inspired by Children and Childhood

I LOVE KIDS' ART. I love everything about it—the unsteady lines, the tadpole people, the lack of perspective, and the revealing family portraits. Children's art makes me smile.

When we were children, drawing was natural and joyful. We could probably draw before we could speak, scribbling away, happy just making marks on the page. Unfortunately, around third grade, the freedom to simply draw for fun wanes as we are taught that there might be a "right" and "wrong" way to draw.

Let's try get back to that child we once were! In this unit we'll scribble, draw toys, and create our own series of monsters under the bed. Rico Lebrun writes, "All great drawing is made by the strategy of innocence with the ammunition of adulthood." We want to practice drawing again with the freedom we had as kids.

Opposite page: This drawing was done by the author's son Christer at the age of six.

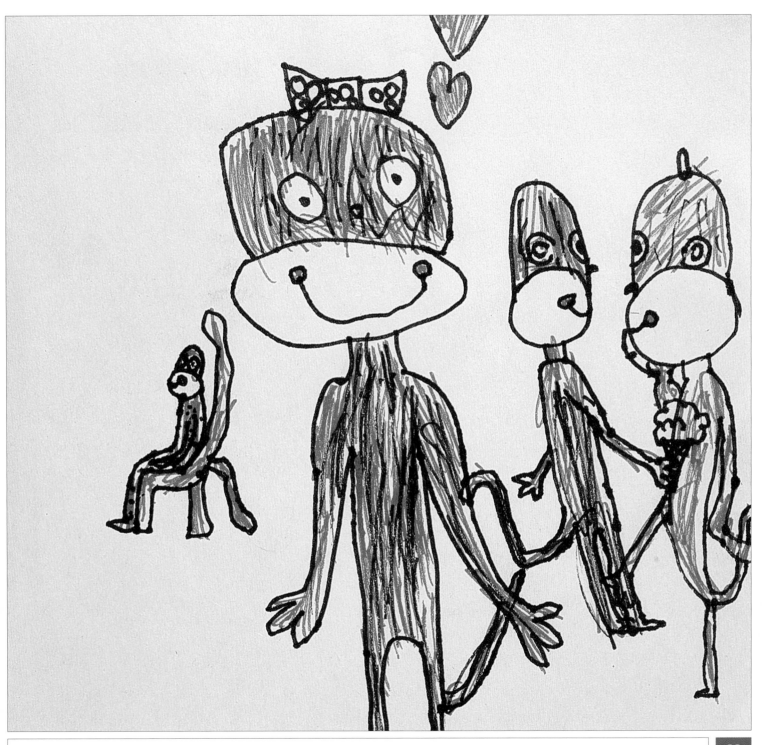

Materials

- several sheets of white card stock, or your sketchbook
- references of subject matter of your choice (animal or people photos, a houseplant, etc.)
- ballpoint pen

"Just as the babbling child makes the sounds that will, in combination, become words, the scribbling child makes the lines and shapes that will, in combination, become recognizable objects."

—Marjorie Wilson

IN THIS LAB, WE WILL TAKE CUES from the toddlers around us who know this truth: Scribbling is fun. In this exercise, you can pretend you're a kid again, but you get to do it as an adult (and apply your adult sensibilities to the end product).

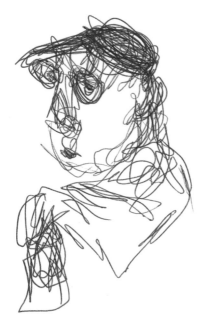

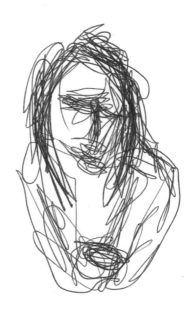

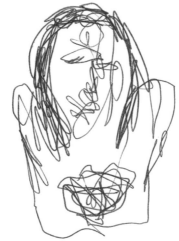

These scribbly drawings were created from life at a local coffee shop.

Instructions

1. Gather your materials. Take a sheet of paper and start scribbling. Just scribble on the page, with no plan as to outcome. Do this for a minute or two until you feel yourself start to relax into the process. Set aside.

2. Now take a second sheet of paper and look at one of your references. Start drawing, still scribbling.

3. This is not supposed to be a contour drawing, though you will be tempted to scribble the outline of your subject. Instead, start from the *inside* of the subject and work outward.

4. Make denser scribbles in the shadowed areas and scribble less in the lighter areas (allowing the white of the paper to show through a bit more).

5. Keep scribbling, keeping your hand as loose as possible, until your intuition tells you the drawing is done. Do at least three more scribble drawings of subjects of your choice.

Putting on Your Drawing Shoes

Physical exercise is a good and enjoyable pursuit, as any athlete will tell you. Yet sometimes it's just so hard to get started. A common trick athletes use to get over the hurdle is to simply put their shoes on: The next thing they know, they are out the door. If you find a similar resistance to drawing, try using scribbly drawings as your "drawing shoes." Sometimes a quick page of throwaway scribbles is all that is needed to get you started drawing.

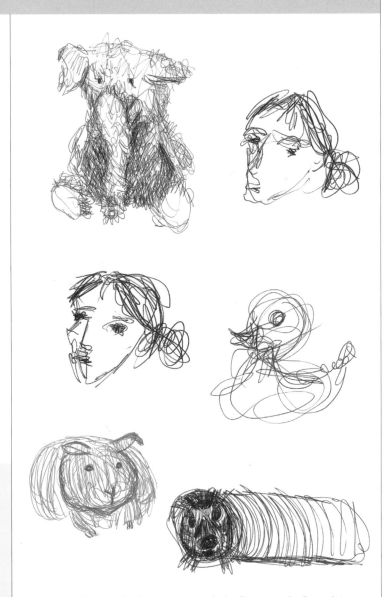

By your using a ballpoint pen, your mind will automatically go into doodling or scribbling mode. Sometimes the tools we pick have associations that will make the process go more smoothly. Hamsters by Blake Green (red) and Angie Fletchall (blue).

Contouring Toys

- 3–5 toys for reference
- several sheets of white card stock
- permanent marker

"Contour drawing helps you see that the things you are drawing aren't things but rather shapes that intertwine and connect."

—Charles Reid

TOYS ARE FUN TO PLAY WITH as children and fun to draw as adults. In this lab, you will create a series of contour drawings using toys as your subject matter.

Even very young children can make successful contour drawings. This drawing was made by an unidentified second grader.

Instructions

1. When rummaging through your child's room or a thrift store for drawing subjects, try to pick toys that are interesting visually but are new to you. Avoid licensed characters such as Mickey Mouse or Barbie: in addition to the copyright issue, their familiarity will actually get in the way of your ability to practice drawing what you see, rather than what you think you see.

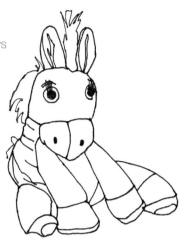

2. Set a toy in front of you in a position that is interesting to you.

3. Pick an edge of the toy and start drawing. Work very slowly, continuously looking at both your paper and the toy, toggling back and forth.

4. Try to get your eye to zero in on the edge of the toy, and move your eyes and hand along the edges at the same speed. Often large portions of contour drawings are done in one continuous line.

5. Remember to breathe.

6. Draw every curve and bump. Do your best to get the proportions right, but don't fuss too much. If you make an errant line, go back to where you went awry and start drawing again. Check your reference constantly and compare it with your drawing.

7. Continue until you feel finished, then move on to the next drawing. Draw the same toy one more time, in a different position if you wish.

8. Repeat for three to five toys, drawing continuously for at least 15 minutes.

A Note about Copyright

Please never copy another creative person's intellectual property and call it your own. This includes drawn, painted, written, sculptural, and photographic works, as well as trademarked and copyrighted items, such as toys or logos. (As an artist, you will of course draw inspiration from anything and everything, but you must be very careful that the works you put out there are your own pioneered creation.) Copyright laws are in place to protect the creator of original and valuable works, which includes you, too! For more info, see www.copyright.gov or www.copyright.cornell.edu/resources/publicdomain.cfm

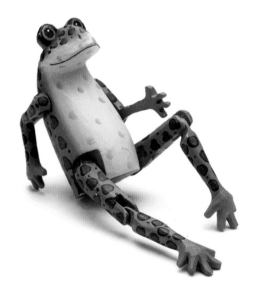

Have you ever noticed that it is easier to draw from a photograph than from real life? That's because in a photograph the image has already been reduced to two dimensions. It's preferable to draw from life so that you can practice translating three-dimensional objects into two-dimensional drawings. However, this photo will give you a toy to draw in a pinch.

One-Eyed Monsters

- sketchbook, or paper of your choice
- black ink pen of your choice
- other mediums of your choice

BECAUSE MONSTERS ARE FICTIONAL, not real, figments of our imagination, and just a bunch of malarkey, in this lab, you will use your imagination only to create several one-eyed monsters. Put those references away!

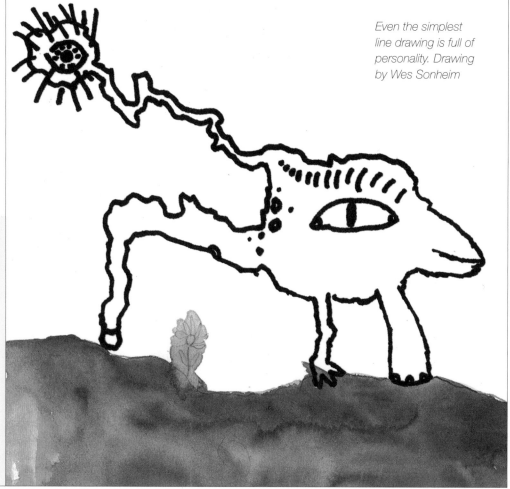

Even the simplest line drawing is full of personality. Drawing by Wes Sonheim

"You can't create a monster, then whine when it stomps on a few buildings."

—Lisa Simpson, fictional character on the television show *The Simpsons*

Instructions

1. Draw an eyeball, large or small, anywhere on the page.

2. Now start adding to your drawing. Do not feel as if you must see the entire creature in your mind's eye before you draw. Just start drawing and let the monster emerge as you go.

3. If you are stumped for ideas, you can take inspiration from words listed in the sidebar, but keep visual references put away for now.

4. If you feel like you've made a mistake, don't worry! Just reposition your pen and continue your drawing. Later, you can work the errant line into the drawing another way (there is almost no mistake that can't be fixed.)

5. Create several monster characters in this manner.

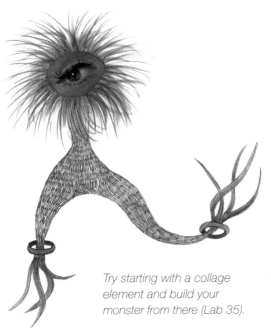

Try starting with a collage element and build your monster from there (Lab 35).

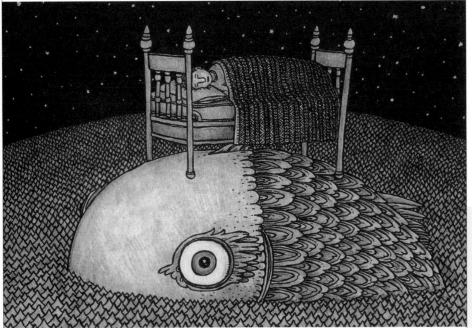

Theo Ellsworth likens drawing to pulling images out of a fog, or slowly turning a focus knob until the picture becomes clear. "I usually start off with a mere inkling of what I want to draw, and it's only through the process itself that the details are discovered. It usually feels more like I'm bringing the images up to the surface of the page than it does putting marks on paper."

Monster Prompts

webbed	short	silly
clawed	stubby	hairy
feathery	fancy	beaked
spiked	wide	pointed
snouted	scary	toothless
furry	winged	worried
plumed	unfriendly	

Drawing Clay Creations

- clay creation done by a child

- any drawing materials and substrates you would like to use

"True art takes note not merely of form but also of what lies behind."

—Mahatma Gandhi

THERE IS SOMETHING TOUCHING about clay creations created by children. They are so imperfect that they are perfect. Aim for the same imperfect quality in your renderings of a child's clay creations.

This elephant was created by the author as a young teenager, and saved from the trash by her sister after the trunk broke off (a sweet memory).

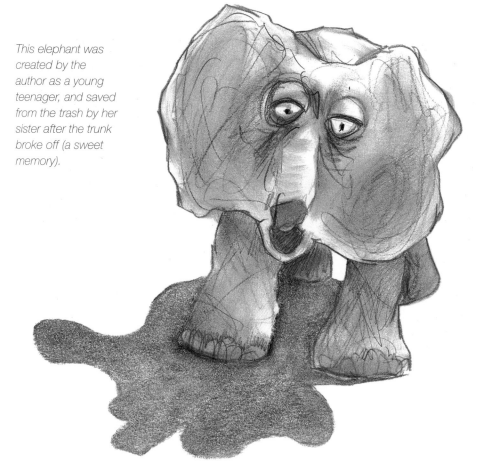

Instructions

1. Choose your drawing materials: pencil, charcoal, or a selection of colored pens or pencils.

2. Place the clay creation in a well-lit area. Take some time to pose it in a position you like.

3. Shine a light on it from one side to emphasize shadows and textures in the clay.

4. Remember to look at your reference more often than at your paper!

5. Embrace the imperfections in both your subject and your own drawing.

6. Take it further by applying different drawing exercises to this subject matter. Blind contours, contour drawings, scribbly drawings, and one-liners are all fun ways to explore these creations.

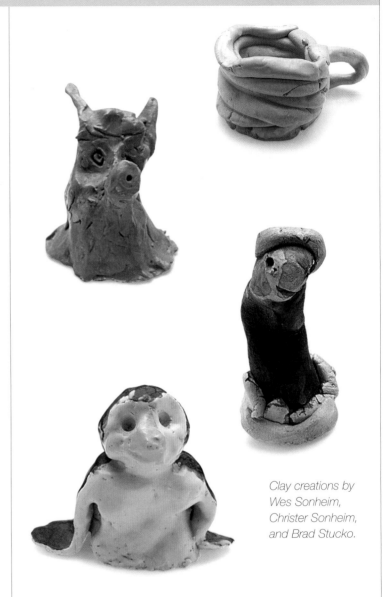

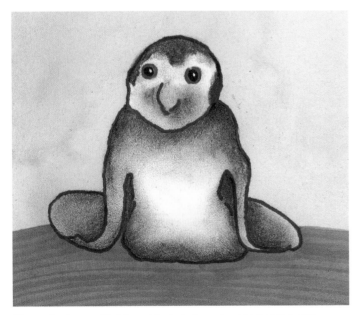

Clay creations by Wes Sonheim, Christer Sonheim, and Brad Stucko.

The author's son Christer while in first grade, created the clay penguin pictured at right, and this rendering was done with watercolor, permanent markers, and charcoal.

Hopefully, you have a child in your life who has created some of these treasures. It's always more fun to draw things that are meaningful to you. But if you can't find some of your own, try drawing from the photographs above.

Collaborate with a Child: Drawings

- paper or other substrate of your choice
- marking or paint tools of your choice

IN THIS LAB, YOU WILL CREATE a piece of artwork in tandem with a child in your life. Before collaborating with a child, be sure to have a straightforward talk with him first, explaining what you would like to do and asking for permission to use his words or artwork in a collaborative piece. Children need to be decision makers in the use of their artwork. This may result in some compromises, but that is the nature of collaboration!

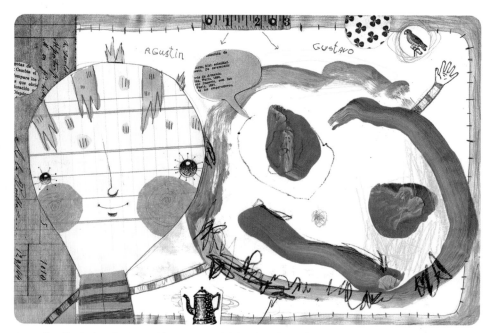

Argentine illustrator Gustavo Aimar created this charming mixed-media painting in tandem with his three-year-old nephew, Augustin.

"The creative part of us is always childlike."

—Julia Cameron

Instructions

1. Start by asking your child to draw a portrait of you on a piece of paper. Encourage her to really look at you while doing the drawing. She can use whatever medium is comfortable for her (crayons, markers, pencil, watercolors, etc.).

2. Then, on the same piece of paper, draw a portrait of your child. Use a different medium . . . something that will contrast well. (For example, if she used pencil, then you could use watercolors or colored markers.)

3. Make the two figures connect in some way—an arm around the shoulder, sitting together at the dinner table, whatever you like.

4. Take inspiration from the looseness of your child's drawing, and endeavor to mimic that freeness as much as possible in your part of the picture. Try not to worry about the finished outcome, but only about making the experience a positive one for both you and the child.

5. Both you and your child should sign the portrait once finished!

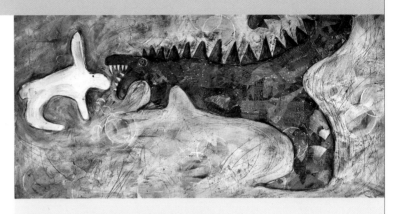

Other Ideas for Collaboration

- Invite your child to draw in your sketchbook whenever she wants. If desired, you can agree on some rules ahead of time (such as, "no drawing over existing drawings" or "It's okay to color in anything I have drawn," etc.).

- Gather a child's batch of drawings around you and create a separate drawing based on her characters.

- Enlarge a favorite kid drawing on the photocopier and transfer onto wood or canvas. This large mixed-media painting (above) was created from a tiny pencil sketch by then eight-year-old Wes Sonheim.

Jill Berry got her whole family involved: girls drew girls, boys drew boys. Family portrait by Jill, Sydney, Sam, and Steve Berry.

Collaborate with a Child: Words

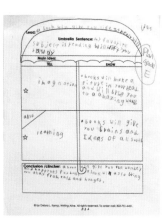

ONCE YOUR CHILD STARTS SCHOOL, he will start bringing home scores of writings in the form of poems, worksheets, grammar exercises, stories, spelling lists, etc. These documents can be the basis for a collaborative drawing or painting.

- enlarged photocopy of a child's writing

- watercolor paper, size of your choice

- vine charcoal

- pencil

- watercolors

- other mediums and substrate of your choice

In this case I was inspired to create a painting based on my son Wes's "umbrella" structure handout on books and reading. This particular piece was completed with layers of gesso, watercolor, charcoal, and pencil on wood.

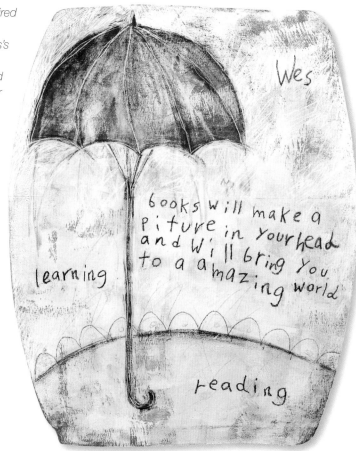

"She's not a mommy anymore. She's an artist."

—Wes Sonheim, at age 4

Instructions

1. Gather your child's writing samples and pick one that speaks to you, or that gives you an idea right away.

2. Enlarge on a photocopier to the size desired. Transfer the type directly onto the substrate by rubbing vine charcoal onto the back of the enlarged photocopy, placing that paper charcoal side down, and then tracing the words with a pencil. (Why trace the words? It is completely up to you, but tracing will retain more of the character of the child's handwriting.)

3. Complete the piece with the mediums of your choice.

Illustrate a Quote

Kids say the cutest things! Search your memory for things you or your kids might have said as children, which might make good subject matter for a drawing. Write them down on a sheet of paper. (If you have trouble finding examples, you can use some of the quotes below.) Illustrate it!

"Mommy! The water's drowning!"

"My race car is gonna be so cool the people will cry."

"I'm tired of the dinosaurs."

"Daddy, saving money is no accident, huh?"

"My eyes are making me shy."

"When you close your eyes you can see your dreams."

"When I grow up I'm going to have seventy children. Seventy."

"You are really young. You're not really old. Well, your forehead is old."

"Blowed kisses are like little ghosties. They can go through cracks in doors."

—Wes Sonheim, age 4

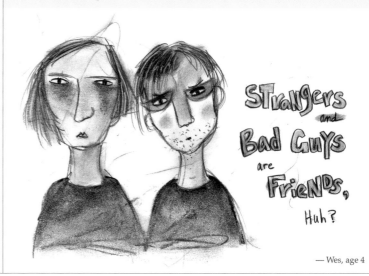

— Wes, age 4

Paper Dolls

- recycled cereal box

- red water-soluble marker

- flat brush

- gesso

- water-soluble crayon, an appropriate skin color

- water-soluble crayon, brown, black, gray, orange, or yellow for hair

- damp rag or paper towel

- pencil

- fixative

- scissors

"What did you do as a child that made the hours pass like minutes? Here is the key to your earthly pursuits."
—Carl Jung

IT'S FUN TO PLAY WITH PAPER DOLLS! (It's even more fun to see grown men play with paper dolls, which happened in our household recently.) Indulge your inner child by creating a personalized set of paper dolls, complete with pets.

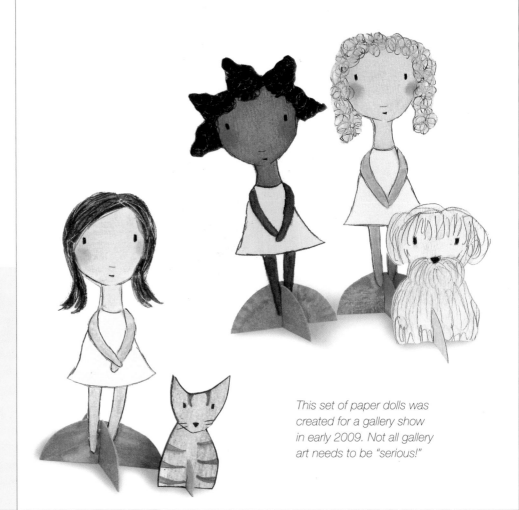

This set of paper dolls was created for a gallery show in early 2009. Not all gallery art needs to be "serious!"

Instructions

1. Cut down your cereal boxes so that you are working with only flat pieces. (You can throw away the folded portions.) With your water-soluble marker, block in your figures. Since these lines will be mostly obscured, there is no need to be fussy with detailing at this step.

2. With your flat brush, paint a layer of gesso over the drawings. Try to get it as smooth as possible. Notice that the marker will show up through the gesso so you can still see your drawings. Let dry.

3. Color the face, arms, and legs with your choice of skin-colored water-soluble crayon.

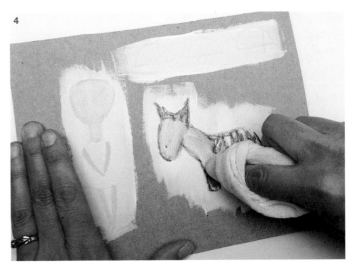

4. Rub smooth with a slightly wet paper towel or rag.

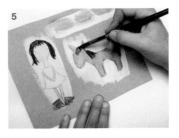

5. Draw the hair with your crayons, using a paintbrush to soften if desired. Outline the entire figure in pencil.

6. If desired, add pastel cheeks with the end of your pinkie finger. Spray with fixative. Cut out your figures, and create stands for them by cutting a circle shape in half and cutting ½" (1.3 cm) slits in the stand and the figure.

7. Play!

Featured Artist

Gustavo Aimar

Graphic designer, children's book illustrator, artist

GUSTAVO AIMAR was born in Buenos Aires, Argentina, in 1973. In 1977, his family relocated to Trelew, in the Patagonia region of Argentina, where he lives to this day. His interest in drawing and in art in general manifested at a very early age. He studied at the Centro Polivalente de Arte of Trelew between 1987 and 1991, where he obtained a degree to teach art and drawing. In 1993, he went back to the city of Buenos Aires to study graphic design.

Since 1986, he has shown his work consistently in shows and galleries, and has been a member of the Illustrator's Forum of Argentina since 2004. He was selected to show his illustration work at the Bologna Book Fair in 2008 and the Bratislava Illustration Biennial in 2009. He's currently devoted full-time to illustrating children's books and doing editorial work for various publications. In his free time, he continues to create art and personal projects.

Artist's Statement

For those like me who work with ideas, images, and concepts—and at the same time are inspired by the world around us—the "fun" factor is very important. When I talk about fun, I mean stimulus, will, connection, interaction. When I work, I'm always looking for these factors in the materials I choose or happen to "find."

In addition to the limits imposed by personal style, technique, themes, or odd habits, materials themselves are a source of inspiration and limitless stimulation.

Animales; *mixed media on paper*

Incorporating elements that allow different levels of "reading" my work is always fun for me. I love to travel around the image, decode it, interpret it, and listen to what it has to say. I'd like to think that this is what I am accomplishing when I incorporate little bits and pieces of paper from old books, labels, postage stamps, and fabric.

Sometimes the materials can unexpectedly suggest different things from what I originally had in mind. It is very important for me to let these variables flow freely and come back to the concept of having fun with your materials and your work.

I work with a lot more freedom when I work for my own pleasure. The case is different if I'm responding to a determined project; I act a bit more cautiously, no doubt about it.

—Translation by Geninne Zlatkis

Caballa Rosa; *mixed media on paper*

Mensajero; *mixed media on paper*

Inspired by Imagination

I USED TO THINK THAT ARTISTS could see the completed image in their mind before they began to draw. But I don't think I've ever had a fully completed idea, creative or otherwise.

I slowly began to realize that the creative process is just that—a process. Ideas are built bit by bit—sometimes in a flood of inspiration, sometimes over long periods of time—and they are not born in a vacuum. Every detail in our world that attracts our attention becomes material for our imagination to experiment with. Dreams are an example of how our imagination creates new things from the jumble of stuff floating around in our heads.

Drawing from imagination is about allowing yourself to accept as fair game anything that pops into your head. All you need is a starting point.

Opposite page: *This drawing started out as an abstract design based on leaves and natural elements ("Abstracted Minutia," Lab 42). The design wasn't working, so I turned the drawing around in an effort to see what the problem was. Immediately I "saw" a rat, drew in the eye (from a photo reference found online), and called it finished! Charcoal on paper.*

UNIT 5

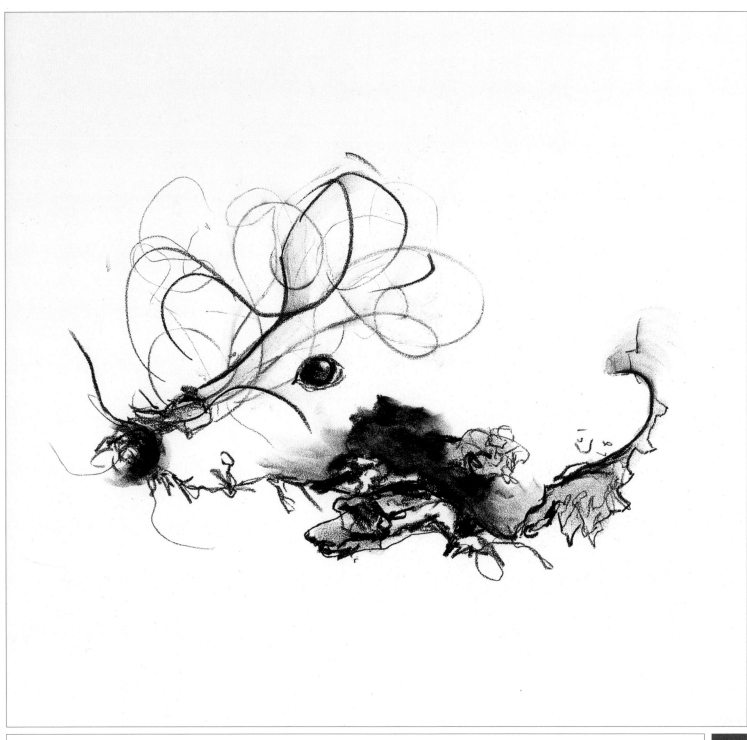

LAB 31 Scribble Drawings

- card stock or your sketchbook
- marker or pencil

THESE DRAWINGS ARE MADE using a random line or scribble as your starting point. The mind is a wonderful thing, and will fill in the blanks in the most creative and amazing ways. Scribble drawings are great to do with your kids in a restaurant or as a warm-up exercise in your sketchbook. Often they will be the starting point for more developed drawings or paintings.

"Limitations live only in our minds. But if we use our imaginations, our possibilities become limitless."

—Jamie Paolinetti

Think of these drawings as practice exercises only, and don't despair if you get a page full of duds . . . again, just try to relax and have fun with the challenge of "making something out of nothing."

Instructions

1. With your pen or pencil, make a random mark on your paper. Try to add a little interest by curving or looping the line back on itself.

2. Now look at the line, turning the paper all the way around. Do you see the beginning of something? A face perhaps? An animal?

3. Finish the drawing.

4. Repeat!

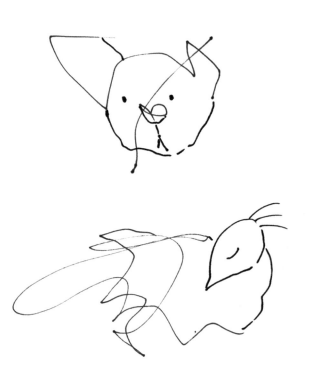

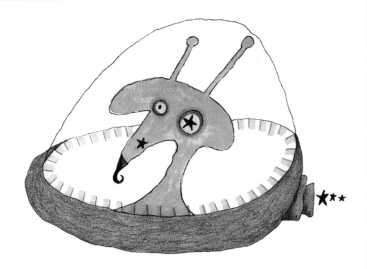

These three watercolor paintings were inspired by scribble drawings that appear in this section. Can you see what inspired what?

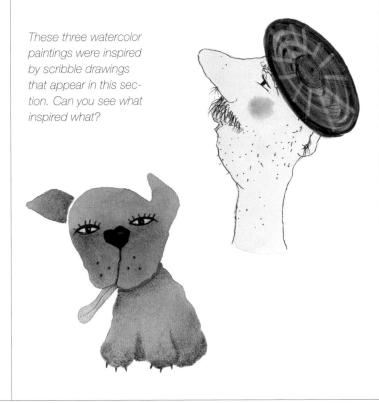

LAB **32** Paint Blots

Materials

IN THIS LAB, YOU WILL FINISH A DRAWING started by a series of random, painted blots (or splotches). There is no right or wrong here; no two people are likely to see the same thing in a blot. As in the Rorschach inkblot test these blots resemble, you may see patterns or similarities in what you pull out of each blot, learning something about yourself along the way.

- ten 5.5" × 8.5" (14 × 21.6 cm) sheets of card stock

- acrylic paint, color of your choice

- spatula or palette knife

- extra-fine-point permanent marker

"To live a creative life, we must lose our fear of being wrong."

—Joseph Chilton Pearce

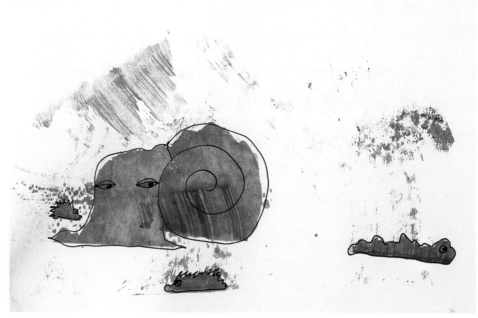

Teesha Moore found this delightfully irritated snail in this multicolored paint blot.

Instructions

1. Squirt a dime-size dab of acrylic paint directly onto your paper.

2. With your spatula or palette knife, scrape the paint across the paper. Do not worry what it looks like at this point; just make an interesting shape. Set aside.

3. Repeat until you have ten pages of paint blots.

4. Once they are completely dry, pick one and just look at it for a moment. Do you see anything? If not, try turning the page 90 degrees clockwise. Do you see anything now?

5. Complete the drawing with your marker.

6. Sometimes you will see an object or animal right away; other times you will need to work a little harder to pull something out.

Taking It Further

You can use collage rather than paint in a similar way. Here, sewing pattern paper was glued randomly onto a piece of watercolor paper and allowed to dry. This creature was then finished with pen and ink.

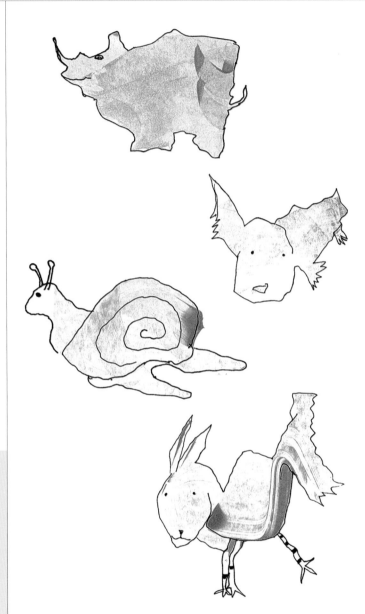

This selection of paint-blot creations was made by Jill Holmes and Pat Eberline.

Doodling on Steroids

Materials

- audiobook or podcast
- any paper or substrate
- ten preselected drawing utensils

"doo-dle (dood'l)—to move aimlessly or foolishly."

—yourdictionary.com

RESEARCH HAS SHOWN that doodling in meetings actually helps you pay better attention, as it keeps your brain occupied just enough to keep you from daydreaming and missing the content of the meeting altogether. Thank goodness, you now have a scientific reason to doodle!

Mixed-media artist Liesel Lund tackled this assignment on the back of a mailing envelope.

Instructions

1. Go to the library and check out an audio-book, or go online and download a podcast of a topic of interest to you.

2. Gather your materials and a glass of water, and turn your mental attention to your audio-book or podcast.

3. Start doodling.

4. Just draw and scribble absentmindedly, making any shapes, lines, squiggles, patterns, designs, or images that your subconscious mind brings out (remember, your mind will be engaged elsewhere).

5. Keep switching drawing tools every minute or so. Use all ten utensils in your drawing.

6. When your book or podcast is over, take some time to study your doodle drawing. You will likely learn some things about yourself, such as that you like purple or you are drawn to patterns and shapes more than to identifiable objects. These types of insights can be valuable as you endeavor to tease out your individual style.

Taking It Further

You can combine the Doodling on Steroids assignment with other assignments throughout this book. We've already seen the doodled dog (page 27), but try applying it to the following labs as well:

Lab 12: For Your Eyes Only (page 42). Doodle an eye, trying to keep the proportions as realistic as possible.

Lab 37: Random Pick Drawings (page 100). Incorporate doodling as texture for part of this piece.

Lab 47: The Office (page 128). This is a perfect assignment in which to employ mindless doodling.

"My personal aesthetic right now is more, more, more!" Liesel takes this exercise a step further by incorporating paints and metallic inks into her paper bag piece (above).

LAB 34 Numbers Game

Materials

- scrap paper for notes
- 5" × 7" (12.7 × 17.8 cm) or 8" × 10" (20.3 × 25.4 cm) sheet of watercolor paper
- any materials you wish

"The best things in life are silly."

—Scott Adams

CHANCE PLAYS A ROLE IN OUR LIVES, so why not in your drawings as well? In this lab, you will create a series of drawings letting chance dictate your subject matter. (Although, as with circumstances that happen in your life, it will be up to you to take what's given and turn it into something you can happily live with.)

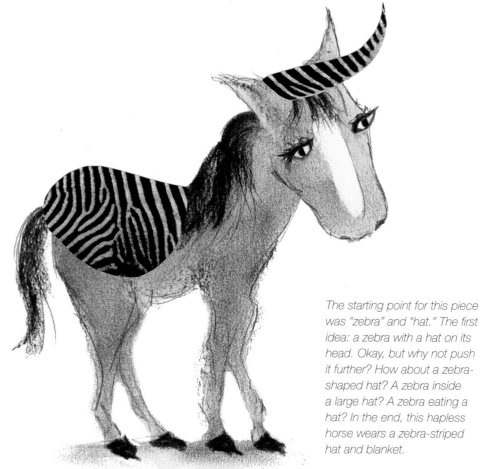

The starting point for this piece was "zebra" and "hat." The first idea: a zebra with a hat on its head. Okay, but why not push it further? How about a zebra-shaped hat? A zebra inside a large hat? A zebra eating a hat? In the end, this hapless horse wears a zebra-striped hat and blanket.

Instructions

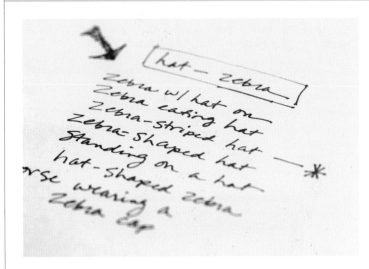

1. ant	1. television
2. elephant	2. hat
3. bulldog	3. bicycle
4. zebra	4. sunglasses
5. bird	5. cowboy boots
6. penguin	6. suspenders
7. mouse	7. ice cream
8. rabbit	8. bathtub
9. poodle	9. refrigerator
10. spider	10. book

1. Without looking at the lists in the sidebar, pick two numbers between one and ten.

2. Now look at the two lists, and write down the corresponding words, one from each list.

3. Take a few moments to write down some ideas about the two words you have chosen. It's possible that your first idea will be the most obvious solution but also the most uninteresting. What other scenarios can you think of? Write those down as well, even if the ideas seem unrealistic, silly, or downright bad.

4. Draw the image that you are most excited about.

Right: The prompts for this piece were "television" and "ant." Since ants can carry up to fifty times their body weight, an ant carrying a television set was a solution based (somewhat) on reality.

Materials

- magazine to cut up
- scissors
- glue stick
- 8" × 10" (20.3 × 25.4 cm) watercolor paper (or size of your choice)
- marking or paint tools of your choice

"I reject your reality and substitute it for my own."

—Adam Savage

AS MIXED-MEDIA ARTISTS, we love collage. (Give us some scissors and a glue stick, and we're happy.) Sometimes collage elements can be added to drawings simply to add texture and visual interest. But in this lab, your assignment is to begin with the collage element, and let it be a springboard for the entire concept of the piece.

Roz Stendahl painted the blue edges in her journal with no preconceived idea of what the pages would eventually become. While browsing magazines on another day, she found a couple in an advertisement and thought it would be fun to have them looking at something in this space. She drew the chicken from her photos and life sketches, and glued down her collage elements as a last step. Collage, mixed-media on paper.

Instructions

1. Flip through your magazine and cut out several images that appeal to you. These should be actual objects, or parts of objects: hands, heads, people, toasters, plants, and so on. Once you have several cutouts, set the scissors and magazine aside and just look at your options. Spend enough time with your cutouts that a seed of an idea starts to form with one of them.

2. Move the cutout around the page and see if any other ideas come to you. Once you settle on an idea, block out your drawing around it.

3. You can either complete your entire drawing first, then glue down your element, or glue first and draw around (and on top of) the cutout . . . your choice! Your method might change from piece to piece, depending on your desired outcome.

4. Whichever way you choose, don't be too quick to glue down. Spend time moving your element around until you get just the right tilt of the head or placement of the hand.

Collage "Dots"

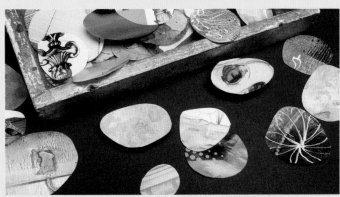

Somewhere in my studio usually sits a little pile of collaged "dots" that I cut out of magazines and reject paintings. I do this when I am avoiding drawing. I basically just absentmindedly pick patterns, colors, and textures that I like.

These dots sit in my studio for a while and inform my color palette, among other things . . . I like having them around! But they eventually make their way into different drawings to add texture and visual interest, such as in this *Fish Out of Water* piece.

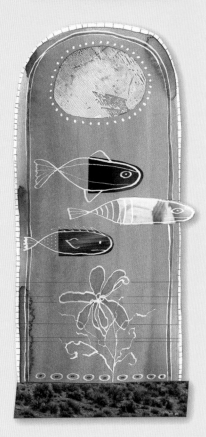

Materials

- sketchbook, or 5" × 7" (12.7 × 17.8 cm) sheets of watercolor paper

- permanent ink pen

- watercolors, or medium(s) of your choice

"Realize that a drawing is not a copy. It is a construction in very different materials. A drawing is an invention."

—Robert Henri

I FIRMLY BELIEVE IT'S OUR DUTY as artists to fill the world with projects and machines that serve Very Important Purposes, such as the machines and projects you see here by Krista Peel.

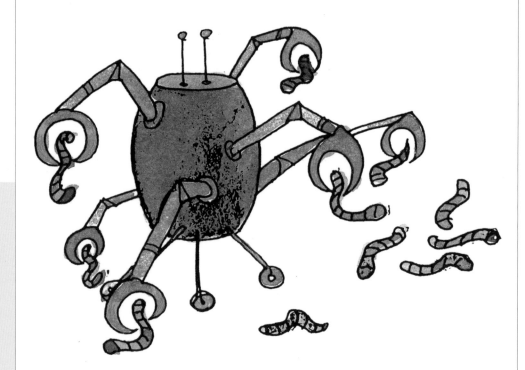

Above: Worm Grabber; *pen and ink, watercolor on paper*

Above left: Leaf Pulse Machine; *pen and ink, watercolor on paper*

All images on these two pages by Krista Peel.

Instructions

1. Draw five items with your ink pen, one per page. Ideas include a tree, a flower, a bed, a house, and a cup. Draw from life whenever possible!

2. Now think of what action or task a machine could do with the object. Examples are "walking," "moving," or "lighting up."

3. Now expand its parts from there (for example, it may need mechanical feet to move).

4. Adding parts such as tubes, gears, wires, or plugs can turn a simple object into a complicated "machine."

5. If you're not sure what action you want, draw in a few parts anyway and see where this leads. Figuring out how those parts should stay upright can turn a leaf into a machine!

6. Complete the piece with watercolors or mediums of your choice.

7. Don't forget to name your machine!

Electric Excuse Collector; *pen and ink, watercolor on paper*

Taking It Further

Rube Goldberg was an illustrator in the mid-twentieth century best known for his popular cartoon series that depicted convoluted and complex devices meant to perform very simple tasks. Take inspiration from Mr. Goldberg by creating your own Rube Goldberg Machine.

Reading and Thinking Machine *by Krista Peel*

LAB 37 Random Pick Drawings

Materials

True Random Number Generator

Min: 1

Max: 20

(Generate)

Result:

7

Powered by RANDOM.ORG

- 5" × 7" (12.7 × 17.8 cm) or 8" × 10" (20.3 × 25.4 cm) watercolor paper

- various drawing materials of your choice

"Creativity is the ability to introduce order into the randomness of nature."

—Eric Hoffer

IN THIS DRAWING, YOU WILL RANDOMLY PICK elements to incorporate into a larger composition. The catch: You will only pick one element at a time, and cannot add the next item until the first is at least blocked in. This exercise will test your problem-solving skills as you work to add incongruent items to your composition. Preplanning is not an option, so relax and enjoy the challenge!

Instructions

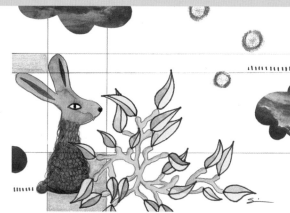

1. Create a list of about twenty items that you would like to draw. (It's important that you draw things that you like and find interesting. Spend some time on this first step, building a list of items that you think would be fun to draw.)

2. Number the items from one to twenty, and go to www.random. org and generate your first random number. Draw the item picked, anywhere on the paper.

3. Pick your second number, and work that item into the composition. Repeat until you have five to nine elements, or you feel that the drawing is complete.

4. Try including at least three different drawing mediums to add even more texture and variety to an already surreal piece.

Above: *The items randomly picked for this drawing were seaweed, leaves, bubbles, lines, clouds, and rabbit (in that order). Note: Don't feel that you must draw all the elements! Here, collaged clouds were added to mix it up.*

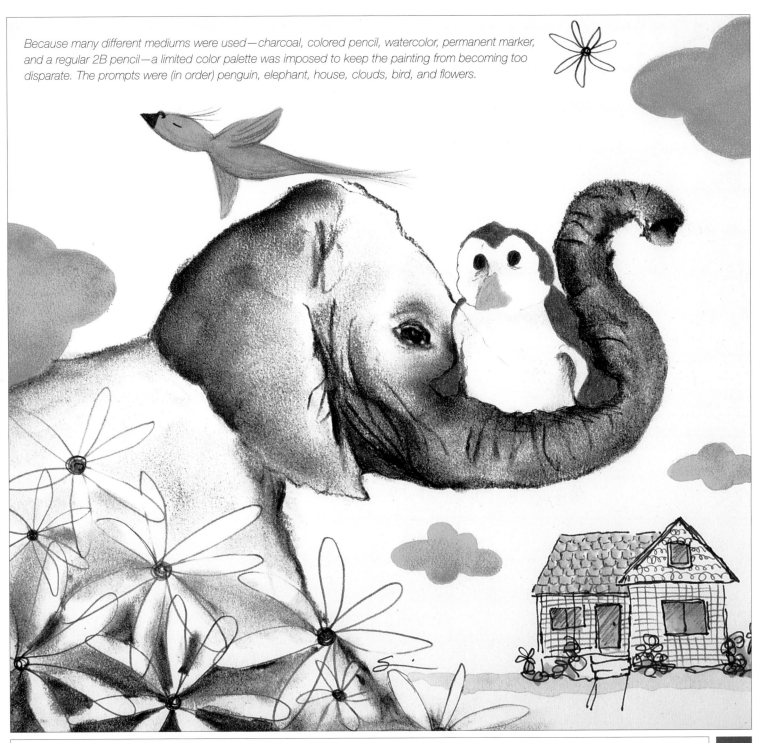

Because many different mediums were used—charcoal, colored pencil, watercolor, permanent marker, and a regular 2B pencil—a limited color palette was imposed to keep the painting from becoming too disparate. The prompts were (in order) penguin, elephant, house, clouds, bird, and flowers.

Sidewalk Crack Drawings

Materials

- digital camera
- 140 pound (64 kg) hot-press watercolor paper, cut down to several 5" × 7" (12.7 × 17.8 cm) sheets
- selection of colored permanent markers
- colored pencils
- mechanical pencil
- vine charcoal
- white gel pen

"Without the cracks in the sidewalks and walls the city cannot breathe."

—Anonymous graffiti artist

CREATE A SERIES OF DRAWINGS using sidewalk cracks as your inspiration. Instead of looking up, to find animals hiding in the clouds, look down, and see what hidden images are beneath your feet.

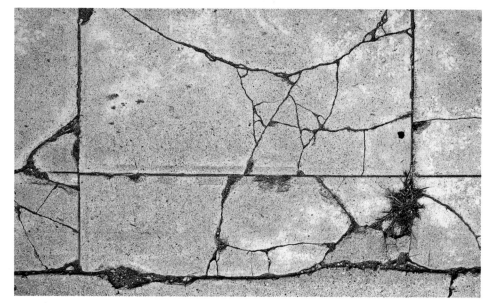

Do you see something in this image?

Instructions

1. Take a walk around your neighborhood and photograph sidewalk cracks that have interesting patterns and shapes. Don't worry too much about photo quality . . . these are for visual reference only.

2. When home, gather your materials and camera and take a look at a random sidewalk-crack photo. Do you see anything? If not, turn it 90 degrees clockwise. Do you see anything yet? Keep turning until something suggests itself—a face, an animal, an object.

Instructions (continued)

3. You don't need to see the entire image. Perhaps you only see a large nose shape and an ear . . . start by drawing those two things, then finish the drawing, using your imagination.

4. Use the colored marker for your outline and then color it in with colored pencils, markers, pencil, charcoal, and/or white gel pen . . . whatever you feel the piece needs.

5. Alternatively, you can sketch your images "live" during your walk (rather than taking digital images) and then finish them up at home.

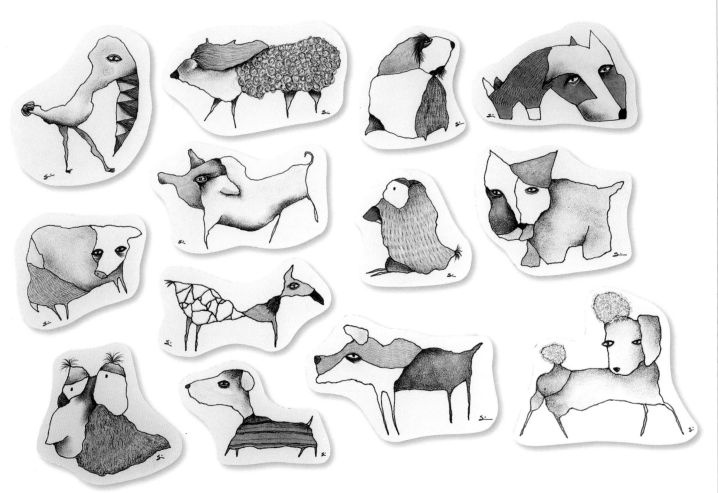

This series of sidewalk-crack-inspired animals was created over a period of several days by the author.

Featured Artist

Liesel Lund

Artist, jewelry designer, teacher

SEATTLE ARTIST LIESEL LUND'S earliest memory is of watching a dragonfly hover over sun-sparkled water. This magical mix of color and refracting light captured her imagination, and her love of this combination often can be seen in her artwork today. Her love of all things pretty has expanded over the years to express itself in many mediums, including watercolor, pastels, acrylics, oils, journals, fibers, fabric, metal, beads, and photography.

Joyous Flight; *mixed media on paper*

Q and A

Q: *What is your drawing routine or practice?*
A: I don't really have a practice; I just draw and paint whenever I feel like it. Drawing is an integral part of my mixed-media work. Painting just feels like drawing with a brush.

Q: From life or your imagination?
A: I do both, but most often I draw from memory or let the drawing come out however it wants to. I think it's important to observe real life and pay attention to the actual colors, textures, and dimensions of things. Both ways are very useful. That way each can inform the other. Both use different artistic "muscles."

Q: *Why do you draw?*
A: I draw because I can't help it! (Well, I can, but if I don't draw or paint, I get grumpy.) Sometimes when life gets really busy and I find myself all worn out, I realize it's partly because I haven't been making any art. Art nourishes me. It is food for my soul.

Q: *Where do you draw, mostly?*

A: Most of the time I draw in my studio, where I can easily reach any materials as they call out to me, sort of like, "Hey, I want to be in there, too!" I do love drawing outside when it is sunny. I love that feeling of, "I'm out drawing because that is what I do, and the bees are out here buzzing because that is what they do."

Q: *Why should anyone draw?*

A: I think drawing is good because it is a great antidote to everyday life: there isn't a "right" answer, it can take little or lots of time, it requires only a pen or pencil and a writing surface, it is freeing, and it uses our neglected right brain—and gives the left one a break. It increases your power of observation, and nourishes the kid part of you.

Q: *Anything else?*

A: I say, "Who cares what it looks like?" Just have fun and twirl that pen in your hand. You are the magician—see what comes out!

Above: Puttin' on the Glitz;
mixed media, beads, wire, tin

Left: Luscious Dreaming;
mixed media on paper

Inspired by Nature

FOR THE PAST EIGHT YEARS, I've lived in a small mountain town in central Colorado. A lot of artists live and work here, and I would say most of them are either landscape painters or are highly inspired by the beautiful scenery around us.

I'm also inspired by nature, but in a different way. When I go for walks, instead of looking up at the mountains and views around me, I'm looking down beneath my feet. Rocks, plants, dirt . . . these are the things I am drawn to the most! Even when skiing, I have to force myself to look up, instead focusing more on the twinkling of the snow beneath my feet.

Are you a big-picture person, or more drawn to the details? Or somewhere in between? Dancer and choreographer Twyla Tharp calls this your "creativity DNA." Mine is definitely in the details. What's yours?

Opposite page: Blue; *collage and mixed media on paper*

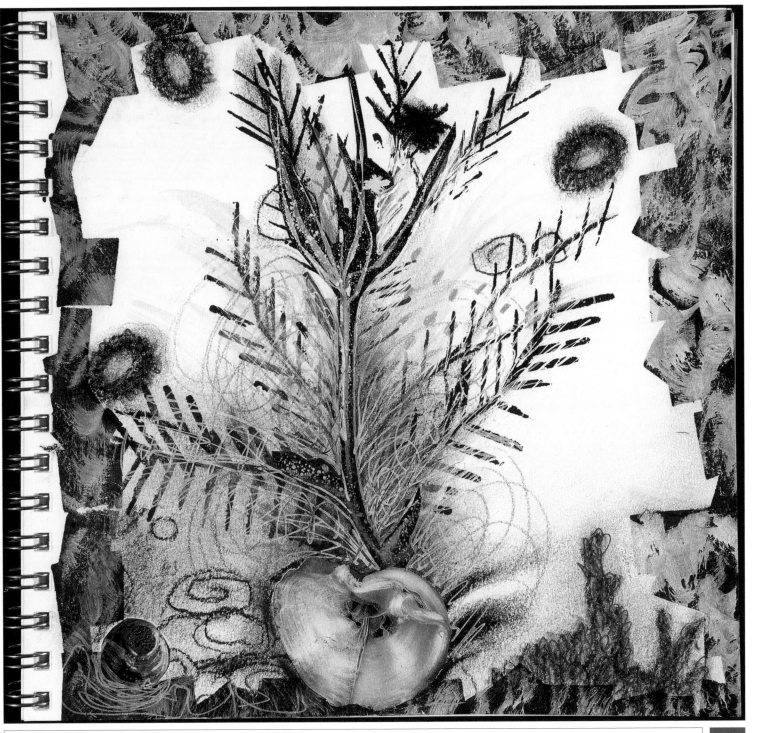

39 Flower Tutorial

Materials

- flower image for reference
- watercolor paper, size of your choice
- pencil
- tortillion (an artist's smudging tool)
- eraser
- watercolors
- white paint pen
- colored pencils
- Sharpie paint pens of various colors
- acrylic paints, application brushes

STEP-BY-STEP INSTRUCTIONS CAN BE HELPFUL in the same way tracing or copying can be helpful—as another tool or exercise that you add to an already robust drawing practice. Even though you are following Liesel Lund's instructions, don't forget to refer to your own reference often!

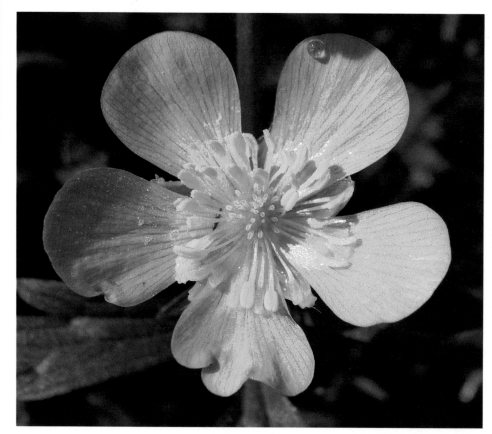

This photograph was taken digitally by Liesel and printed out for easy reference. You can also find flower references in gardening catalogs, magazines, books, and, of course, your own garden!

"Nobody sees a flower really; it is so small. We haven't time, and to see takes time—like to have a friend takes time."

—Georgia O'Keeffe

Instructions

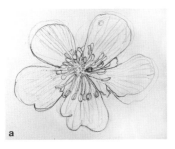

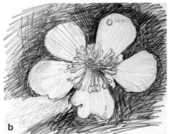

1. Outline the flower shape in pencil. (a)
2. Add shading with pencil, keeping your hand loose and the line scribbly. (b)

3. Smudge the shadows, using the tortillion. (c)
4. Use your eraser to pull out highlights. (d)

5. Add watercolor washes. Let the layers dry between applications. (e)
6. Add dots and lines with a white paint pen. (f)

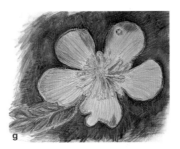

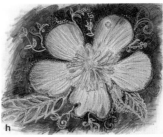

7. Add more color with colored pencils. (g)
8. Add even more marks with Sharpie paint pens in various colors. (h)

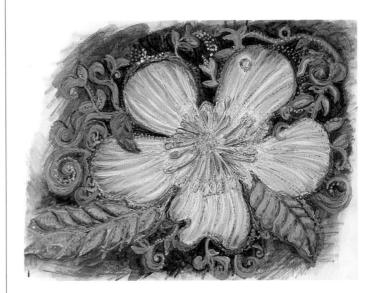

9. Add acrylic paint highlights. (i)

Bug Me!

BUGS MIGHT BE ANNOYING or even scary to deal with in real life; but to draw, they are superb: A treasure trove of unusual combinations of color, line, and form! Today you will create your own stylized bug collection, complete with numbers and labels.

- bug imagery
- 8" × 10" (20.3 × 25.4 cm) sheet of watercolor paper
- black ultra-fine-point permanent marker
- markers, colored pencils, or other mediums of your choice
- optional: rubber stamp alphabet set

Instructions

1. Go online or to your library and search for "bug collection" imagery.

2. Find a bug you would like to draw and create a contour drawing with your smaller marker. Look at your reference often! (Note: You can block in your contour drawing lightly with pencil first, if desired.)

3. Now thicken some of your lines. There are no rules; just add weight to some lines and keep others thinner. Stop when the shapes please you.

4. Color your bug with the medium(s) of your choice.

5. Repeat steps 1 through 4, varying the size and type of your bugs, until your bug collection is complete; say, 5 to 9 bugs altogether.

6. With your pen or rubber stamps, number your insects and create a key somewhere on your page. Note: Now that you have stylized your bug drawings, take it further by being creative with the naming of your bugs!

"The mosquito is the state bird of New Jersey."

—Andy Warhol

1. Corratau Beetle
2. Buvaraccio Butterfly
3. Spiratook Botty Fly
4. Vamudock Beetle
5. Buffle Thor Butterfly

This collection was created using Sharpie and Copic markers, neon-colored markers, and colored pencils.

- several sheets of white card stock, or your sketchbook
- ink pen of your choice

"I only went out for a walk and finally concluded to stay out till sundown, for going out, I found, was really going in."

—John Muir

COMBINE YOUR LOVE OF NATURE with your drawing practice. In this exercise, you will complete a series of mini drawings by carefully observing and drawing different elements you come across during your walk.

Sherrie York created this pen and ink drawing during a hike in the mountains of central Colorado.

Instructions

1. Gather your materials and go to a favorite hiking or wilderness spot. Draw anywhere on the page something—anything—that catches your eye.

2. In this exercise, you are aiming for realistic renderings, so take the time to carefully observe your chosen subject. Keep your line fairly loose; plants, rocks, and trees rarely are made up of completely straight lines.

Why Drawing in Pen Is Good for You

Pencils are wonderful drawing tools, and erasers certainly have their place. But, when teaching, I've found that if erasers are allowed, more time is spent erasing than actually drawing (this seems to be true for both children and adults). By working directly in pen, you eliminate the very possibility of erasing and therefore can focus more on the drawing part. Scary? Maybe, but oddly freeing as well. Think of it this way: The pressure to do perfect drawing is diminished when using pen and ink, since no one expects perfection on a first try. Once the pressure is off, better drawings often emerge.

3. Now continue walking, stopping and drawing other things that you find interesting.

4. It's okay to leave certain elements out of your drawing (such as leaves caught in a bush, for example). Since you are making a drawing and not a photograph, you are free to use your artist's prerogative and simplify, if desired.

5. Vary large and small, close-ups and horizons. Don't worry about scale . . . just make a page of impressions of your outing.

6. Continue until you fill your page.

7. Go back to your studio and connect the drawings somehow, either with words, lines, a line of ants, or anything else you can think of to pull the "walkabout" drawing together into one cohesive piece.

This is the author's take on this assignment, rendered in Sharpie colored markers on the trail and finished with Copic markers in the studio later.

Abstracted Minutia

- various tiny natural items
- watercolor paper, 8" × 10" (20.3 × 25.4 cm) or larger
- soft charcoal pencil

> "[Abstract art] should be enjoyed just as music is enjoyed—after a while you may like it or you may not."
>
> —Jackson Pollock

GET OUT YOUR MAGNIFYING GLASS! In this lab, you will take inspiration from the minute details of natural items, and turn them into something else altogether.

The drawings on these two pages were created using a piece of tree bark, dried leaves, and other bits and pieces found out and about.

Instructions

1. Gather tiny natural items—tiny rocks, bits of leaves, flowers, tree bark, part of a pine cone—and bring them home to your studio.

2. On your drawing table, arrange your elements in a design that is pleasing to you.

3. The goal is to make these drawings somewhat abstract. No one else needs to ever know what inspired them. This takes some of the pressure off; you can just concentrate on trying to record the texture and feeling of the detailing of an item.

4. Start drawing. Lightly block in the shapes and forms of your overall design, then begin recording textures, using the charcoal in different ways to create different effects. For example, a delicate leaf might be rendered with a light, airy line; texture on a rock could be laid down harder and then smudged with your finger.

5. Keep your lines as loose and free as possible.

6. Think lights, darks, and balance. Don't overwork; stop when that little niggling voice inside you tells you that you're finished!

Food for Thought

Picasso once said, "There is no abstract art. You must always start with something. Afterward you can remove all traces of reality." What do you think about this statement? Do you agree? Disagree?

The versatility of charcoal used to its best advantage makes it a favorite medium for many artists.

Materials

- watercolor paper, or your sketchbook
- 2B pencil
- pencil sharpener
- eraser

CREATING ART EN PLEIN AIR is the act of drawing and painting outdoors. Mosquitoes, blaring sunlight, wind, or freezing hands may all be part of the experience, arguably actually enhancing the artwork by infusing reality into the process. Have fun!

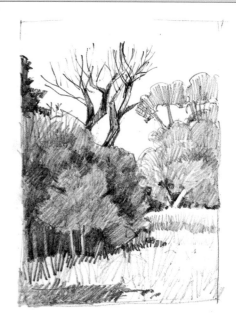

Right: River Meadow *took Sherrie York about fifteen minutes to create.*

Below: Pasture; *pencil on paper, fifteen minutes*

All of the art on these two pages by Sherrie York.

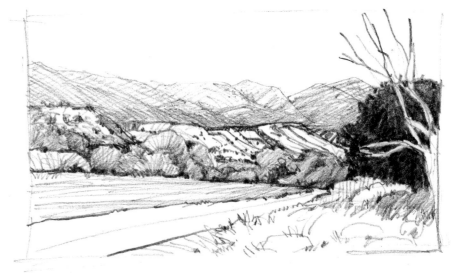

*"Ever charming, ever new,
When will the landscape
tire the view?"*

—John Dyer

Instructions

1. In this exercise, you will create several value studies while working outside. (For more about on-site drawing, see "A Day at the Zoo, Part I," Lab 4.)

2. Start by drawing squares or rectangles on the page to contain the compositions. Make these small; about 2" × 3" or 3" × 4" (5.1 × 7.6 cm or 7.6 × 10.2 cm), so several can fit on a page. It's easy to get tangled up in a too-complex drawing if you don't give yourself some limits in the beginning,

3. Very lightly sketch in the basic shapes of your composition, but build up the bulk of your drawing with shading and tone rather than line.

4. Try reducing the entire scene to just four tonal values (from light to dark).

5. Don't overwork these drawings! They are meant to be relatively quick studies.

What Is Value?

Value is the term used to describe the brightness or darkness of a shaded area. We use value to create the impression of three dimensions by observing and rendering how natural light falls on the object. The first step toward putting value into your drawings is learning to see how highlights and shadows determine the shape and form of the objects we see in the world.

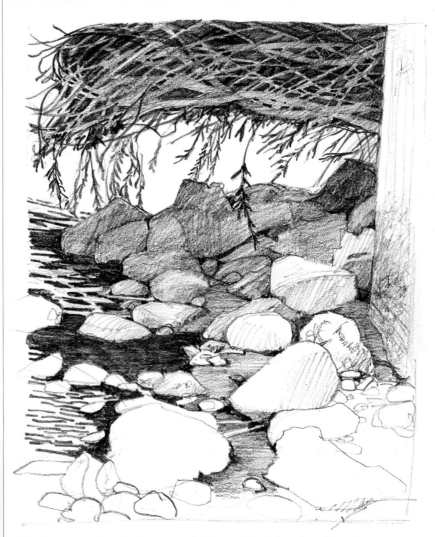

Sherrie used a Staedtler Lumograph 2B pencil for this series of drawings. Under the 291 Bridge; *pencil on paper, forty-five minutes*

Birds, Birds, Birds!

- bird references
- paper of your choice, plus scrap paper for practice
- vine charcoal

"Use what talents you have; the woods would have little music if no birds sang their song except those who sang best."

—Reverend Oliver G. Wilson

IT IS GREAT FUN TO DRAW BIRDS. Birds are fun for me to draw because they come in so many wonderful shapes and sizes—it's hard to go wrong! They are also fun to draw because of the personality of each bird—they are quirky and silly and serious and goofy . . . each is different! In this lab, you will work with vine charcoal, starting with realistic renderings and then moving on to more stylized renderings (in charcoal or another medium of your choice).

People seem to either love or hate charcoal. Now's your chance to see if you like getting your hands dirty!

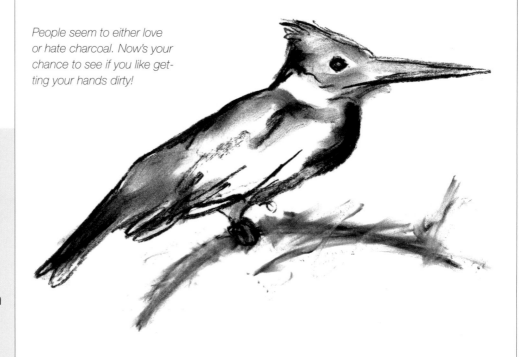

Instructions

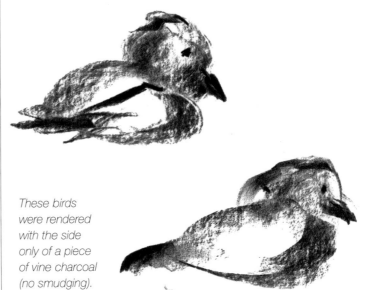

These birds were rendered with the side only of a piece of vine charcoal (no smudging).

1. Before you start drawing your birds, spend some time just making marks on a scratch piece of paper with the charcoal. Draw straight lines, squiggly lines, and circles. Vary your pressure to create lighter and darker lines.

2. Now use your finger to smudge the lines.

3. Practice using the side only of the charcoal to make lines. Now apply slightly more pressure on the tip, darkening one edge.

4. Draw a series of eight to ten birds from photo references, using some or all of these charcoal techniques.

Taking It Further

After you have spent some time drawing birds from references, you will have more confidence when branching out in more stylized directions.

Drawing Out Your Passions

- timer
- 5–10 sheets of white card stock
- pencil or pen that you like writing with
- several magazines to cut up
- scissors
- glue stick

"Nothing great in the world has been accomplished without passion."

—Georg Wilhelm Friedrich Hegel

IF WE ARE TO SPEND TIME DRAWING, painting, and creating, it is very important to seek out subjects of interest so that you will spend the time doing it! There is nothing worse than struggling with a creative piece when there is not enough interest to sustain you through the hard parts. (Yes, there are always hard parts.)

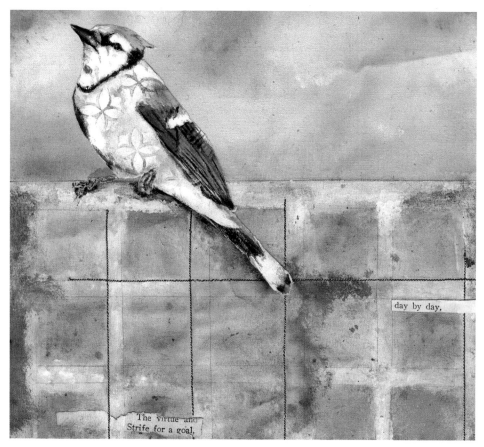

Tracie's passion for all things natural is evident in all of her mixed-media work. Images on these two pages by Tracie Lyn Huskamp.

Instructions

1. Set aside about forty-five minutes for this exercise, and find a place where there will be few distractions.

2. Set your timer for seven minutes. With a pen and piece of paper, start writing. If you don't know what to write, just write, "I don't know what to write," until something comes to you. You should write continuously. Write whatever comes to mind, and try not to judge!

3. When the timer rings, set down your pen and gather your magazines, scissors, and glue stick. Set your timer for twenty minutes.

4. In the next twenty minutes, you will create a collage from words and imagery found in your magazines. Everyone approaches this differently . . . some people will spend the first fifteen minutes tearing or cutting, then glue everything down during the last five minutes. Others will work more methodically, laying down their first piece of collage in the first five minutes and building from there. Do whatever feels right for you, but check your timer every once in a while so you are not caught empty-handed at the end of twenty minutes. (Time will go faster than you think!)

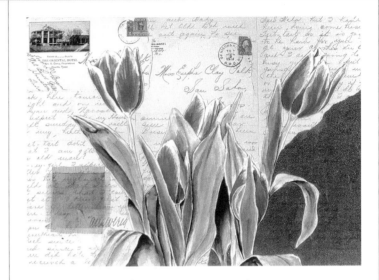

5. When the timer goes off the second time, set your pages of writing and collage next to each other. Read over the things you wrote. Highlight or underline two key phrases that stand out to you. Now look at your collage. Do you see any common themes?

6. You may be surprised at what comes out. One workshop student was surprised that her common themes from these two exercises was news and politics, not nature (she was a floral painter). I asked if she had ever thought about making art that reflected these interests. (She hadn't.) It's possible that painting flowers provided a much-needed break from the seriousness of her political and social interests. However, it's also possible that nature wasn't much of an inspiration to her after all, and she was painting florals for reasons other than interest or passion! Whatever the case, it is important to ask yourself these types of questions.

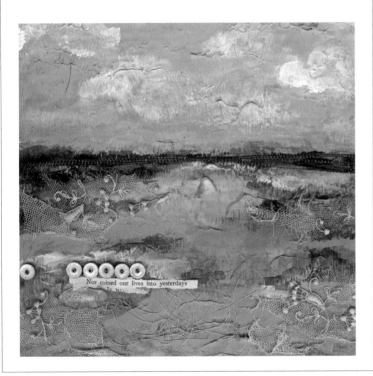

Above: Tulips; *mixed media on canvas*

Right: March Landscape; *mixed media on canvas*

Featured Artist

Geninne Zlatkis

Artist, illustrator, graphic artist

GENINNE D. ZLATKIS was born in New York, but shortly after, her parents began traveling around South America, where she lived in seven different countries and went to several English-speaking schools. She studied architecture in Chile for a couple of years before graduating as a graphic artist in Mexico.

She works in a variety of mediums, including watercolor, ink, and pencil. She also sews, embroiders, and hand-carves rubber stamps. She lives high above a mountain forest at 9,842 feet (3 km) above sea level close to Mexico City with her husband, Manolo, their two very creative boys, and a cute border collie named Turbo.

Q and A

Q: *How often do you draw?*
A: I am a firm believer that practice makes perfect, so I draw every day. I surround myself with things that I love and that inspire me—good music, and an open window to look outside and listen to the birds sing. I draw because it's fun and it makes me happy. Drawing to me is like an itch that needs to be scratched; I need to do it.

Q: *Erasers or no erasers?*
A: When I was in college studying architecture, I had a professor who was totally against erasers and he banned them during the whole first year. I learned a lot that year. Not being able to use an eraser taught me to go with the flow

Right: Bird #17; *collage/mixed media on paper*

and not dwell on the imperfections but to use or disguise them as part of the plan. I think it made me more creative. I rarely use erasers now, but I do have a couple of them on hand just in case.

Q: *From life or your imagination?*
A: A combination of both. I almost always use photographs as reference when I do my line work and after that I let my imagination play around with textures, colors, and details.

Q: *How does drawing affect your mixed-media work?*
A: Drawing is always an integral part of my work, whether it's a collage or water-color. I usually draw first and build up from there.

Q: *What are your favorite drawing materials?*
A: The humble yet wonderful no. 2 pencil, old fountain pens, and watercolors are my absolute favorites.

Q: *Can you remember your earliest drawing?*
A: I can remember the first box of crayons my mom gave me at age three and the delight of seeing all of those different colors waiting to be used. I remember a big fat coloring book that came with the crayons. I've been drawing ever since.

Above: Autumn Leaves; *acrylic paint on leaves*

Below: Paint Chip Birds; *collage/ mixed media on paper*

Inspired by Books and Culture

MAKING SOME SORT OF RECORD of our lives seems to be a basic human need. We write or draw, take photographs, and tell our stories to whoever will listen. Creating art is a way of expressing our feelings about the stories we live and the stories of others.

In my Girls series, I am telling the story of my life at that moment. It's not so much about what the girls are doing, but what they are thinking and feeling. Here is an excerpt from my artist statement about this series:

As I work on and complete each painting, I am struck by how similar this process is to my life in general. Starting with imperfect wood (we are imperfect as people), and using a wide variety of materials and techniques (work, relationships, art), we can transform the imperfection into something beautiful. It also reminds me how I want to approach my life: when I get stuck or am afraid that I'll "ruin" a painting, I remind myself that this is My Painting/My Life: I can put whatever I want in it.

Opposite page: Fairy on Turtle *is based loosely on Aesop's* The Tortoise and the Hare. *From the Girls series, mixed media on wood*

UNIT

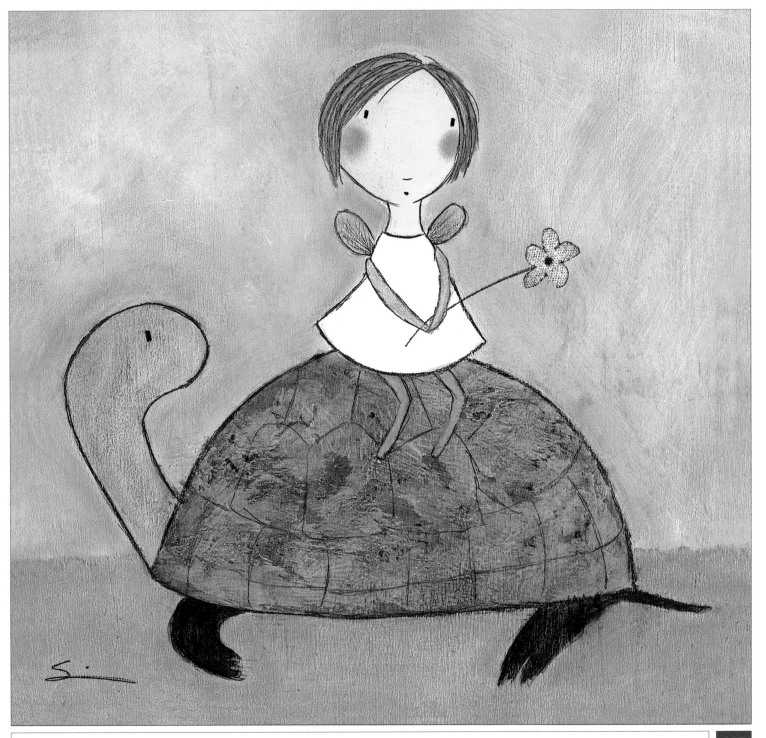

SALIDA REGIONAL LIBRARY

- library books
- 5–10 sheets of card stock, or your sketchbook
- pen of your choice

"I sometimes think there is nothing so delightful as drawing."

—Vincent van Gogh

I TRAVEL OFTEN TO DIFFERENT CITIES for workshops and love to add an extra day to the trip to explore the area—not necessarily to shop or go to museums—but to visit the local library! Browsing library shelves is one of my favorite things to do. In this lab, you will go to the library, get a stack of books, and draw!

This sketchbook page was created during a two-hour drawing session at the Bellevue Regional Library in Washington State.

Instructions

1. Go to your local library and spend about five minutes grabbing books that catch your eye visually.

2. Settle yourself comfortably at a table and start flipping through the book on the top of your stack. If you like something, draw it.

3. Continue drawing items, not worrying about where they fall on a page. If they overlap each other, that is fine. If you make a mistake, that is fine. You are basically just giving yourself a practice drawing session and documenting things that you find interesting.

4. The amount of time you spend on this exercise is completely up to you. For some, thirty minutes will be all you can take. For others, two to three hours might be the right amount of time.

Right: You can use these practice drawing sessions to inspire more finished drawings. This piece was created from imagination after spending a few minutes just looking at (and meditating on) the five practice pages you see here. You can especially see the influence in the trees.

The Office

- stickers, Post-Its, old ledger paper, and so on
- ballpoint pens, highlighters, and so on

"The brain is a wonderful organ; it starts working the moment you get up in the morning and does not stop until you get into the office."

—Robert Frost

LIKE IT OR NOT, the workplace is a large part of our culture. In this lab, you will ignore your collection of art supplies to create a series of drawings that use only pen and paper products found in an office environment.

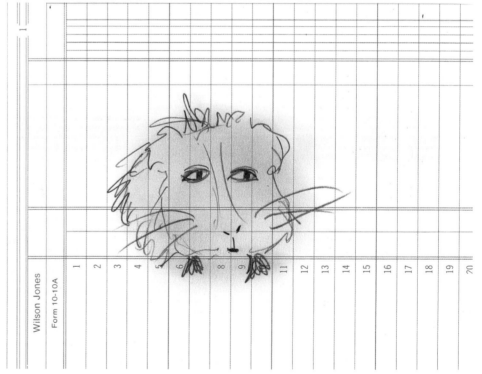

This drawing was created with a 2B pencil and older ledger paper as a substrate.

Instructions

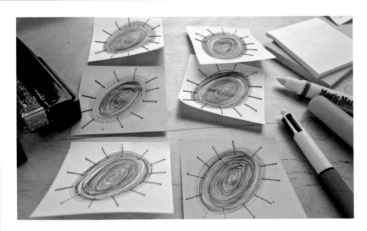

1. If you work at an office, block out a week of lunch hours to work on this exercise. Often there are extra meeting rooms you can reserve for this purpose.

2. Consider asking a like-minded friend to join you! We all need people to keep us accountable, bounce ideas off of, and collaborate with.

3. Gather items that you might find in a regular workplace. They may include cheap printer paper, Post-Its, index cards, receipt books, ledger paper, stickers, file folders, cardboard boxes, phone message pads, yellow highlighters, ballpoint pens, and huge black marking pens.

4. Start experimenting with your materials. Try scribbling, one-liners, or any other starter exercise to get the ideas flowing.

5. After a time, something should "click," when the seed of an idea is born. Go with that impulse, even if it seems unresolved at first.

6. It's possible that your series won't really start at this point, but will evolve into something different as you work on it. This is completely normal!

7. Complete five to twenty works that complete your series.

Who says art must be created on good paper or canvas? In Gustavo Aimar's lively piece, the texture and writing of the vintage office paper actually adds to the overall charm of his artwork.

Materials

- sketchbook
- black waterproof ink pen
- watercolors

> *"A traveler without observation is a bird without wings."*
>
> —Moslih Eddin Saadi

THE NEXT TIME YOU GO ON A TRIP, work in extra time to slow down and draw the surroundings around you. Your experience will be much richer for it! Enjoy Krista Peel's tips for drawing while on the road.

Above: Indiana Beach; *mixed media on paper*

Above left: Neriod; *mixed media on paper*

All artwork on these two pages by Krista Peel.

Krista Peel: On the Road

- My first goal is to find a nice place to sit. Perhaps I'm lazy, but I'm most productive in a comfortable sitting spot. I like parks, city squares, fountains, and porches.

- Pick one thing you would like to draw. Perhaps it's the roof of a building, a flower, or the ground in front of you. Just pick one thing and start.

- Don't worry if you think your chosen subject isn't "good enough." Some of my favorite pieces are those of table settings at a restaurant or diner on the road. When I look at these paintings later, I remember all kinds of things: where it was, the time of day, what the place looks like, what we talked about, what it smelled like . . .

- Continue your line drawing until you are pleased with the way the shapes fall on the page. Then get out your watercolors!

- When painting, don't forget to leave the white. It took me a while to figure out that the white, or empty, areas make the water-colored areas even better.

- If you don't have enough time during the day to paint, just focus on getting a couple of drawings done. Then set up a little watercolor station in your hotel room at night and take your time painting.

- Adding shadows is the most wonderful trick. Remember to put in the shadows of the objects and the whole thing comes to life. Really. Try it.

- I like to mix the colors on my palette first. I spend a lot of time mixing; it's something I really enjoy. Use lots of water!

- The only thing I like more than traveling, is painting. And drawing. And jewelry making. Also dioramas, roller coasters, swimming, mini-golf, and discussing movies. Oh, and Tiki drinks.

Above: St. Croce Square; *mixed media on paper*

Left: Table; *mixed media on paper*

LAB 49 Illuminated Pages

Materials

- a book
- ballpoint pen, or other mediums of your choice

"Everything in the world exists in order to end up as a book."

—Stéphane Mallarmé

WE'VE BEEN TAUGHT not to draw in books, and yet most of us have marked up textbooks or novels by underlining or starring passages . . . why is drawing so different? In this exercise, you are set free to draw in a book . . . just make sure it's your own book that you are illuminating!

Fourteen-year-old Wes Sonheim made an assignment to read Homer's Iliad *much more interesting for himself by doodling in the margins. Double benefit: a completely personalized edition of a classic read.*

Instructions

1. You might need to talk to yourself a bit to get over the "sin" of drawing in books. Try to remember that it is your book, after all, and that marking it up in this way is no different from the underlining you may have done in college. If that doesn't work, take a deep breath and just start! (If you just can't draw in a new book, try drawing on an already damaged book instead.)

2. Pick a book and give yourself an assignment from ideas in the sidebar at right.

3. Draw!

The author's copy of Watership Down *had deteriorated upon reading, and so the loose pages became canvases for a series of rabbit drawings and water-color paintings.*

Assignment Ideas

- Doodle aimlessly in the margins, without thought to content or outcome.
- Draw right over the text (whether it remains readable is up to you).
- Illustrate passages as you go in the margins on a miniature scale.
- Create full-scale drawings at the beginning or ends of chapters only.
- Are you reading a book about relationships? Then draw people or animals interacting with each other. Nature? Use the book as a field journal and draw from life.

Materials

- substrate of your choice
- marking or paint tools of your choice

USE YOUR DRAWING SKILLS IN TANDEM with paint, collage, and graphic design to create a poster advertising a movie, theater, or event . . . real or imaginary.

"Before you are able to draw, you have to learn to see, and you learn to see by drawing."

—Mick Maslen

Artist Jill Berry hand-drew the woman and other elements, then scanned everything into the computer and digitally created a fake poster for a popular art retreat.

Instructions

1. Pick a movie, play, or event that you would like to "advertise." These can be real or imaginary.

2. Go online or to the library and look up poster designs to give you an idea of how designers through the decades have put together playbills, movie posters, and the like.

3. Once you have settled on a basic idea, start drawing. If you have access to a computer and will be compiling your poster digitally, you can draw your poster elements separately. Otherwise, block out the entire poster design lightly in pencil, including type, in one larger drawing.

4. Complete the poster in the medium(s) of your choice.

Taking It Further

A poster doesn't make any sense if it isn't printed and distributed. Print at least ten copies of your poster and post them in store windows, bulletin boards, and other public venues.

The author's son Christer played the Tin Man in a local production of The Wizard of Oz. *This poster was created with the specific actors and costuming in mind, as well as inspired by the actual movie posters advertising the original movie.*

- favorite fairy tale
- sketchbook
- pen or pencil
- drawing or painting tools of your choice

"Fable is more historical than fact, because fact tells us about one man and fable tells us about a million men."

—G.K. Chesterton

LITERATURE IS REPLETE WITH STORIES you can illustrate: fairy tales, fables, and Greek mythology are just a few areas you can mine for lively subject matter. In this lab, you will choose a fairy tale to illustrate using your chosen mediums.

Teesha Moore rendered three other versions of The Three Little Pigs *before she came up with this version, her favorite.*

Instructions

1. Pick a favorite fairy tale and read it twice . . . once at a normal speed (for the story), and a second time more slowly (to get nuances you might you have missed the first time around).

2. During the second reading, take time to write down key words that tell the story visually in your mind. For example, in *Little Red Riding Hood*, some words could be "red," "basket," "grandmother," "woods," "whiskers," and "teeth."

3. In your sketchbook, draw five to ten thumbnail sketches of ideas of how to interpret the story (or part of the story) visually.

4. Execute your illustration in the medium(s) of your choice.

Taking It Further

Add your own twist to the story! In this rendition of *Little Red Riding Hood,* the wolf is a kindly character, even offering to give the girl a ride to grandmother's house. Mixed media on wood.

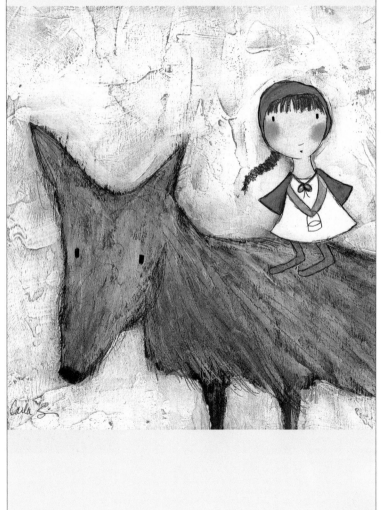

Exploring Story: Your Own

- three 5" × 10" (12.7 × 25.4 cm) sheets of 140 pound (64 kg) watercolor paper
- scissors
- needle and thread to bind the book together
- favorite drawing or painting tools
- collage fodder
- glue stick

"A story should have a beginning, a middle, and an end . . . but not necessarily in that order."
—Jean-Luc Godard

IN THIS EXERCISE, you will work in the exact opposite way you did in the previous lab. Instead of starting with a story and planning your composition, you will start by working on your story (in book form) with only a single drawing, and let the process dictate how the story emerges.

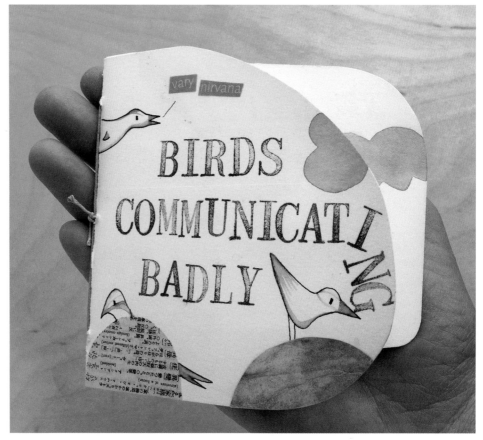

This mini book, Birds Communicating Badly, *was created during a journaling retreat in a room of forty people. Sometimes "alone" and "quiet" are not the best conditions to create in!*

Instructions

1. Round the corners of the three pieces of paper. Do not try to make them match; instead, make them as different as possible. Fold each piece in half (though not necessarily in the middle).

2. Bind together at the folds with needle and thread, to make an irregularly shaped book.

3. Draw something, anywhere in the book. Do not feel as if you must start with the cover; sometimes starting on the inside can be less intimidating.

4. Once you've made your first drawing, see if the placement or the object itself suggests another idea. If so, draw (or collage) that in. If not, flip through your collage materials or your sketchbook and see if something pops into your head at that point. When it does, don't think—execute it!

5. Now turn the page. Most likely, part of the drawing on the first spread will be peeking through the irregular shapes. Now look at this new spread and see how you can continue the story you started, using the portion of the first drawing as a starting point.

6. Continue the process, turning pages, adding to already started drawings, until your storybook is finished.

The Process: Birds Communicating Badly

- My first idea was a book of birds communicating with collaged speech bubbles. I went to my stash of magazines to look for interesting speech-bubble material.

- After a while nothing was really happening . . . it wasn't easy . . . it didn't flow. But what I did find was an advertisement for a berry farm. Hmm.

- The original idea got usurped by this new thought . . . "What if I only used the words from this advertising copy and put it into the birds' mouths instead?" So I cut out the words and started to try to make sentences and thoughts out of them.

- But that wasn't working, either. There just weren't enough words to create complete sentences . . . they just sounded jilted . . .

- Poof! Birds communicating badly could be the theme of the book!

- After that, I spent the next hour or so in a manic frenzy to finish the book. So, so fun.

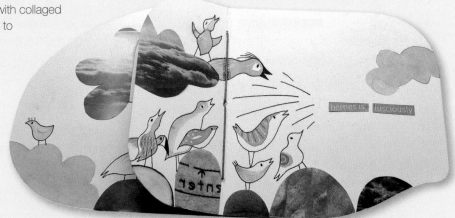

Above: *Watercolor, ink, and collage on paper*

Featured Artist

Jenny Kostecki-Shaw

Children's book illustrator, gardener, traveler

WHEN JENNY KOSTECKI-SHAW WAS LITTLE, she would sit in a box and draw pictures. Eventually, her studio expanded to her closet where she made up characters and neatly archived them in blue binders (including hundreds of made-up Smurfs). "I would sit on the green shag carpet under hanging clothes with my older sister Renee sitting in her office on the far other end of the long, skinny closet. She wrote poems and said I could be her illustrator," Jenny writes. "My oldest brother Freddy and his friend Kevin Brimmer drew a lot, and I thought they were the coolest. I decided then that I'd always be an artist. When I was eight, I won my first art contest with a drawing of Santa Claus. I still remember the phone call—it was the first time I ever remember crying because I was happy." Jenny finds a lot of inspiration for her art and stories from her life: traveling, adventures, family, friends, her dog, other pets, and memories.

Q and A

Q: *Do you have a drawing routine or practice?*
A: When I travel, I'm addicted to my sketchbooks, filling them with anything and everything strange and beautiful, even if it doesn't make sense. My home life is so quiet and simple, and traveling is the opposite—full, exciting, adventurous—so it's easy to gather up inspiration like mad. It fuels me for a long time.

Lately, being a new mama, I tend to draw whenever the urge hits. I often doodle while riding in a car, or on bits and scraps of paper such as receipts, napkins, or torn brown grocery bags. I tend to draw with mood—sometimes fast and

Swan Ride; *mixed media on paper*

gestural, sometimes very detailed, other times simple line. I love making blind contours, and I often draw with my left hand. It gets me out of my head.

Q: *From life or your imagination?*
A: Both. I've gotta satisfy my waking and dreaming life. My favorite will always be drawing the nude model from life.

Q: *Why do you draw?*
A: I wouldn't feel alive if I didn't. It's like breathing. It's how I best express myself. Other reasons, too . . . I draw sketches for clients, ideas for paintings, and simply to record something I want to remember, like the odd position my dog is sleeping in.

Q: *What are your favorite drawing materials?*
A: Sticks, natural or carved just right, dipped in ink. Actually, anything dipped ink . . . And henna, fat orange Ferby pencils, and thin Sharpie markers.

Q: *How does drawing affect your paintings and other mixed-media work?*
A: Drawing is the foundation for a painting. It's what holds it together. It is also about exploring for me. When I just play with drawing and surrender, paintings emerge out of some deep subconscious place.

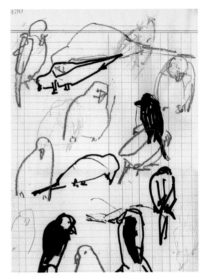

Above: Bird studies; *mixed media on paper*

Below: Temples *series; mixed media on wood*

Contributors

Gustavo Aimar
www.gustavoaimar.blogspot.com

Jill K. Berry
www.jillberrydesign.com
jill@jillberrydesign.com
(also Sam, Steve, Sydney, and Jill for
The Berry Family Portraits)

Elizabeth Dunn
sedunn3@verizon.net

Katherine Dunn
www.katherinedunn.us
katherine@katherinedunn.com

Pat Eberline
peberline@msn.com

Theo Ellsworth
www.thoughtcloudfactory.com

Angie Fletchall
angiedawnf@hotmail.com

Kayla Gobin
Salida, CO

Blake Greene
Greenie119@aol.com

Kay Hewitt
Carpinteria, CA

Jill Holmes
www.jill-holmes-art-journal.blogspot.
com
jill.holmes@gapac.com

Tracie Lyn Huskamp
www.TheRedDoor-Studio.com
TheRedDoorStudio@yahoo.com

Jenny Kostecki-Shaw
www.dancingelephantstudio.com
coloredsock@mac.com

Liesel Lund
www.liesellund.com
www.liesel.typepad.com

Teesha Moore
www.teeshamoore.com
artgirl777@aol.com

Conrad Nelson
www.conradnelson.net
cwn@rockymountains.net

Krista Peel
www.kristapeel.com

Brenda Beene Shackleford
www.betweenassignments.blogspot.
com
beenebag@yahoo.com

Christer Sonheim
www.thesomaproject.org

Wesley Sonheim
slathazer@sonheimphoto.com

Roz Stendahl
www.rozworks.com
roz@tcinternet.net

Brad Stucko
www.zanemultimedia.com

Karine M. Swenson
www.karineswenson.com
karine@karineswenson.com

Sarah Wilde
www.curiouscrow.typepad.com/
curious-crow/
curiouscrow@rocketmail.com

Sherrie York
www.sherrieyork.com
sy@sherrieyork.com

Geninne D. Zlatkis
www.geninne.com
geninne@gmail.com

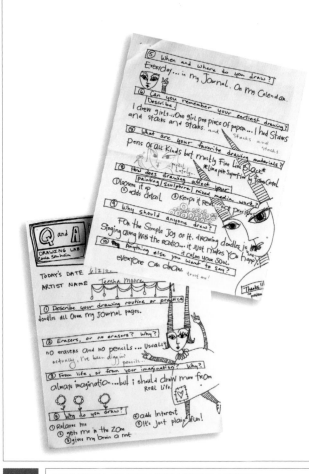

Resources

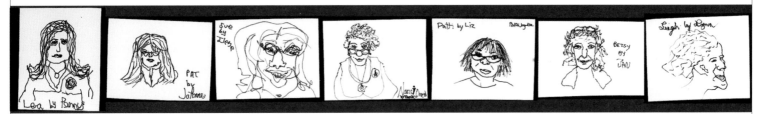

Additional Credits

WRONG-HANDED PORTRAITS

Cynthia Anderson, Patty Barker, Tess Bedoy, Debi Billet, Leigh Bunkin, Helen H. Campbell, Joanne B. Derr, Nanci Drew, Marrianna Dougherty, Elizabeth Dunn, Suzanne Duran, Pat Eberline, Patti Finfrock, Lea Finnell, Angie Fletchall, Lani Gerity Glanville, Carolyn Gimplowitz, Blake Greene, Reenie Hanlin, Jennifer Hard, Kelly Hardman, Jan Harris, Kim Henkel, Kay Hewitt, Carolyn Huie, Ginger Iglesias, Adrienne Keith, Cathy Keith, Katie Kendrick, Hermila N. Knutson, Lorraine Lewis, Maddy Lewis, Jeannine Luke Kenworthy, Brenda Marks, Dori Melton, Jane Miley, Syd McCutcheon, Paula McNamee, Teesha Moore, Lynn Nicole, Jo Anne M. Owens, Carol Parks, Lynn Peffley, Sally Peters, Denny Peterson, Penny Raile, Helen E. Rice, Marion Scales, Brenda Beene Shackleford, Lorna Sommer, Mary Stanley, Lorraine Stribling, Suanne Summers, Rena Tucker, Savannah van Vliet, Carin Wallace, Ilene Weiss, JoAnn White

Favorite Books on Drawing and Creativity

The Artist's Way (Tarcher, 2002) by Julia Cameron

Drawing with Children (Tarcher, 1996) by Mona Brookes

Experimental Drawing (Watson Guptill, 1992) by Robert Kaupelis

Keys to Drawing with Imagination:

Strategies and Exercises for Gaining Confidence and Enhancing Your Creativity (North Light Books, 2006) by Bert Dodson

The Natural Way to Draw: A Working Plan for Art Study (Mariner Books, 1990) by Kimon Nicolaides

Acknowledgments

Thanks to the following:

- All the contributing artists
- Steve
- Wes
- Christer and Christi
- Mary Ann Hall
- Numerous friends and family members
- And my students

About the Author

CARLA SONHEIM is a painter, illustrator, and popular workshop instructor at art retreats such as Artfest and Art & Soul. She is known for being a gifted facilitator and loves to help adult students recover a more childlike play approach to creating. Carla's "Girls" paintings are showcased in numerous galleries nationwide, as well as in private and corporate collections.

website: www.carlasonheim.com

blog: www.carlasonheim.wordpress.com

email: carla@carlasonheim.com